FAR FROM HOME

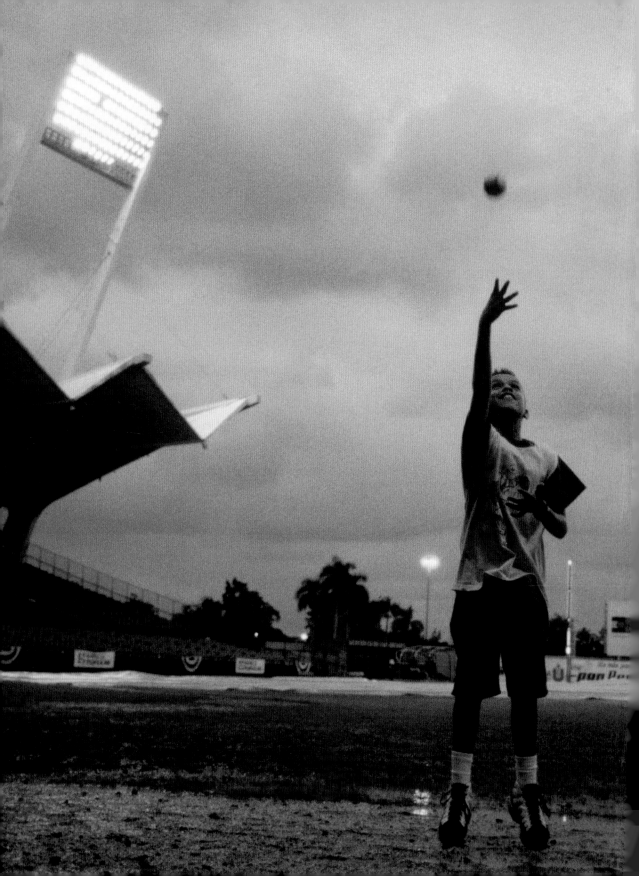

FAR FROM HOME

LATINO BASEBALL PLAYERS IN AMERICA

TIM WENDEL & JOSÉ LUIS VILLEGAS

NATIONAL GEOGRAPHIC

WASHINGTON, D.C.

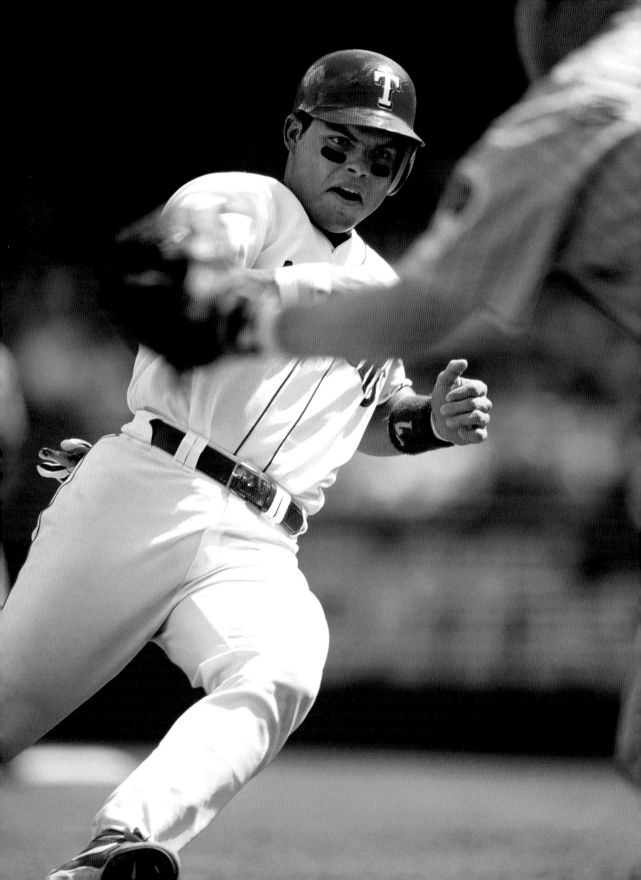

CONTENTS

Preceding Pages
THE FUTURE
A boy tosses a ball inside the famous Hiram Bithorn Stadium.
PUERTO RICO
1995

(Opposite)
IVAN RODRIQUEZ
Born in Puerto Rico, Rodriguez is considered one of the best defensive catchers in baseball history.
1999

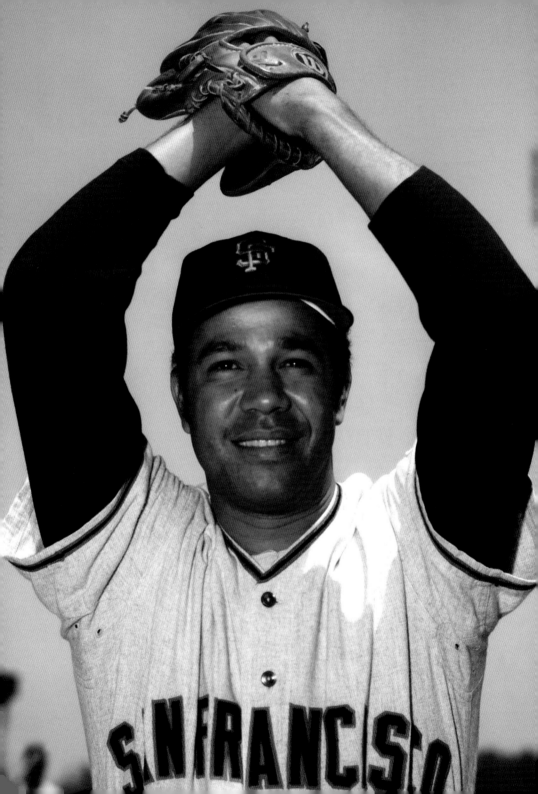

As a boy growing up in the Dominican Republic, all I wanted to do was play baseball. That is what made all of us happy. The playing conditions were not good, but it was baseball. I was a shortstop until I was 12 years old and then I saw Bombo Ramos pitch. I decided to be a pitcher too, and that was the beginning of my trip to the major leagues. To play in the major leagues in the United States —the best baseball in the world— was a dream come true.

In my day, any kid who wanted to play major league baseball had to work very, very hard. It was difficult to come to the United States and not speak English. We didn't know how to order anything besides water and chicken. Today it is very different. During my four years as the Sports Minister in the Dominican Republic, I have seen the academies the major league teams have built. They are beautiful schools in this country. They prepare players to play the best baseball in the world, and the players learn how to live as men wherever they play. To see so many superstars from Latin America now, it's a beautiful thing. It makes me proud of the things we went through.

Major league baseball is much better today because of the growing number of Latino players—good players and superstars. It is part of the growth of baseball around the world. Congratulations to Commissioner Bud Selig and the creators of the World Baseball Classic. It was wonderful to watch teams from Asia, Europe, and so many Latin American countries competing against each other. The next tournament in 2009 will be great for baseball and the whole world. No part of the baseball world is isolated anymore, as Latino baseball was for a long time. Baseball has been played by Latin Americans since the 1800s, and it is a rich history, as you will read in this book. Today, with so many opportunities and with new Latino stars emerging every year, the history will become even richer.

STATESMAN

After an illustrious 15-year career in major league baseball as a right-handed pitcher, Marichal was inducted into the National Baseball Hall of Fame in 1983.

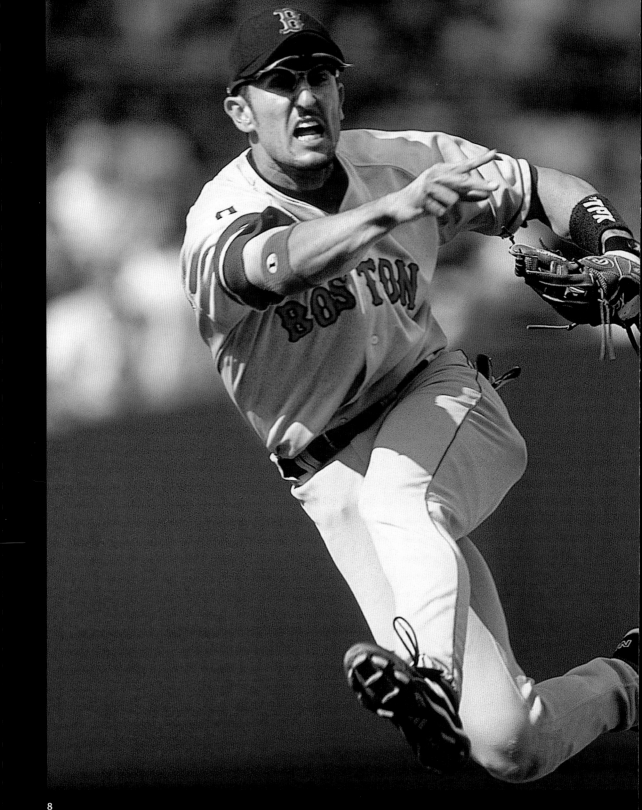

Shortstop Nomar Garciaparra throws the baseball to first base during another pivotal series against the New York Yankees in 2002.

Pittsburgh Hall of Fame right fielder Roberto Clemente slides into third base during the 1971 World Series.

Alex Rodriguez in the on-deck circle during a 2006 game against the Baltimore Orioles.

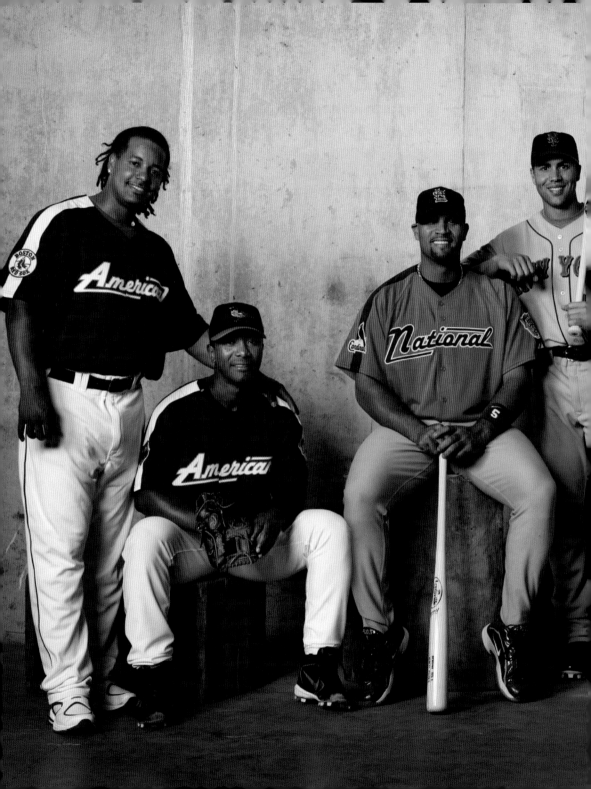

Dubbed the "Latin Kings" by *Sports Illustrated* magazine in 2005 are: *(L-R)* Manny Ramirez, Melvin Mora, Albert Pujols, Carlos Beltran, David Ortiz, Miguel Cabrera, Miguel Tejada and Vladimir Guerrero.

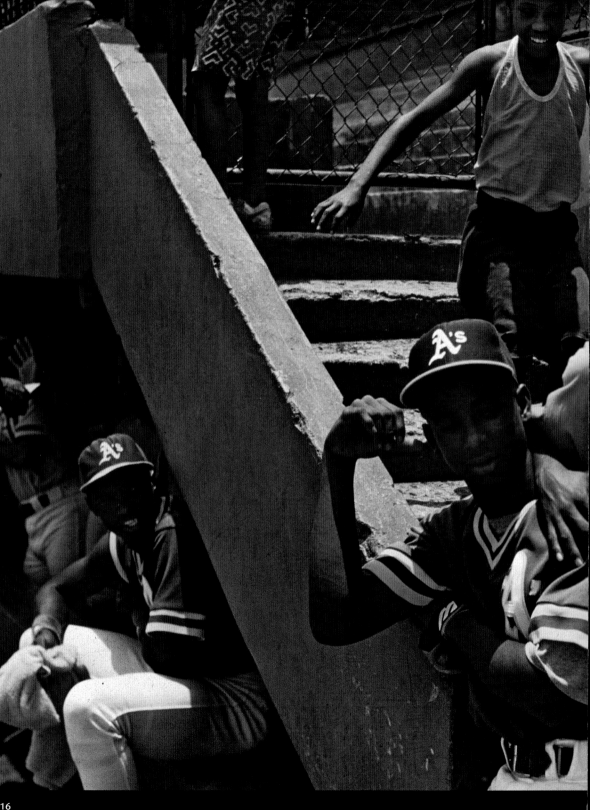

Eddie Lara, a shortstop for the Oakland Athletics in their minor league farm system, speaks with some of the neighborhood children in Santo Domingo, the Dominican Republic, during a summer league game in 1993.

"Los Mets" talk in the visiting dugout during a game at Great American Ball Park in Cincinnati in 2006. From left to right, Julio Franco, Orlando Hernandez and Pedro Martinez.

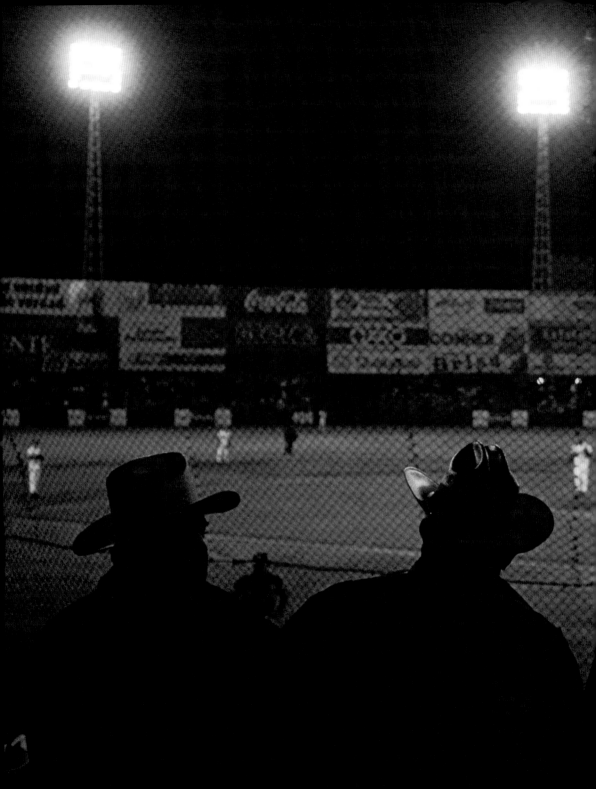

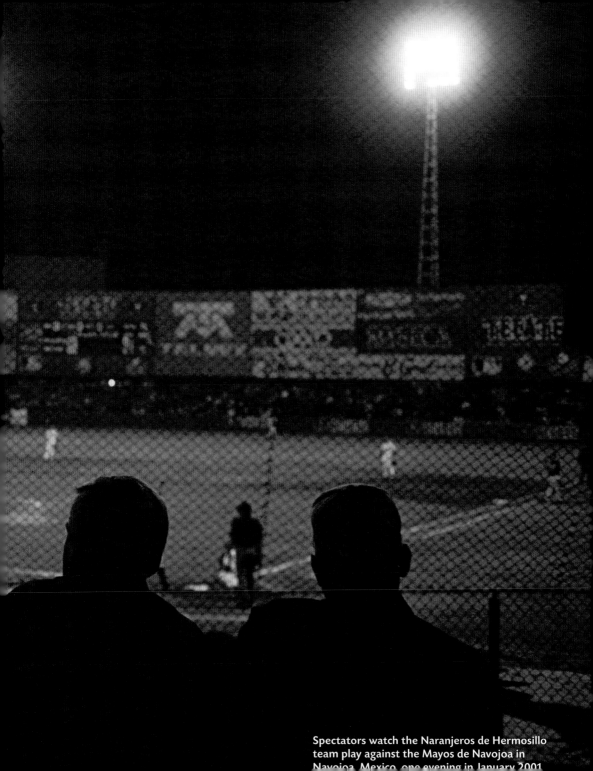

Spectators watch the Naranjeros de Hermosillo team play against the Mayos de Navojoa in Navojoa, Mexico, one evening in January 2001.

FIRST BASE

THE APOSTLES

THE APOSTLES:

Assumption is the mother of all screw-ups. Baseball manager Tony La Russa told me that in the mid-1980s when I first began to cover Major League Baseball. I was the "swing man" for the San Francisco *Examiner*, moving from one side of the San Francisco Bay to the other to cover each of the two ballclubs—La Russa's Oakland Athletics and the San Francisco Giants. La Russa, in his inimitable way, had given me the key to understanding the real story behind the rise of Latinos in baseball.

As the new baseball season began in 2007, Latinos comprised more than one-quarter of Major League Baseball players. The majority of these players came from Venezuela, Cuba and the Dominican Republic. A glance at the roster of leaders in hitting and pitching revealed a perennial list of Latino all-stars: Vladimir Guerrero, Magglio Ordonez, Johan Santana, Manny Ramirez and Albert Pujols. When *Sports Illustrated* asked a panel of baseball experts who they would draft first if they were starting a team, Jose Reyes and Alex Rodriguez were among the top picks. At the minor league level, the trend continues, with almost one-half of those playing at Triple A and below coming from outside the United States, many of them Latino.

One of the assumptions about why Latinos have become such a force in baseball starts with their lifestyles back home. Many of the recruits come from poor neighborhoods in the Caribbean and in Latin America, so they may have a better understanding of true hunger, literally and figuratively. Because they often don't have money or access to buy expensive toys such as Nintendo, DirecTV and iPods, they play ball. And they have the chance to play ball year-round because of the warm climate.

While such statements can be true, the underlying assumption underneath does not include the larger issues—an extensive history and a close-knit community—that perhaps better explain why the face of baseball has changed so dramatically in recent years. Baseball is still an important part of the community in many parts of the Caribbean and Latin America. In many ways, it's reminiscent of how things used to be in the United States when New York Giants player Willie Mays played stickball in the streets with the kids. He didn't live at the end of a gated cul-de-sac as some superstar athletes do today. Mays and his peers a generation ago were still a part of their communities. Even the best box seats in a stadium can't offer the familiarity that comes from somebody who lives on your street.

In 1992, the U.S. Olympic baseball team was scheduled to play a

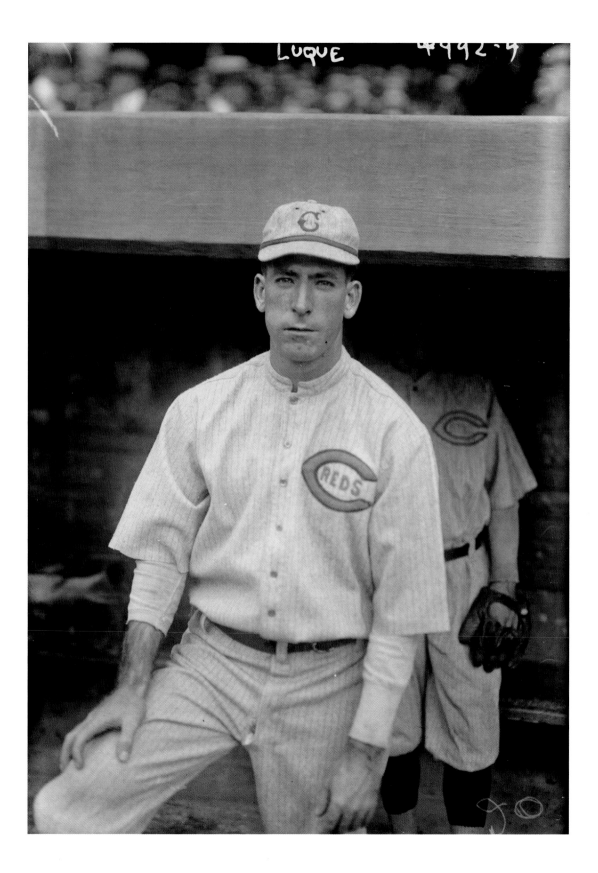

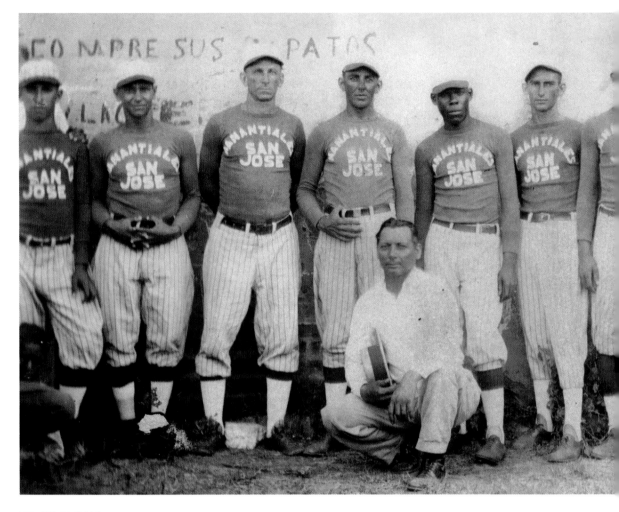

THE SUGAR MILLS

Players often learned the game by playing with colleagues who worked in the sugar trade.

SAN JOSE, CUBA

CIRCA 1930

three-game exhibition series against Team Cuba prior to the Olympic Games in Barcelona. I flew to Cuba to cover the event and gained a rare glimpse inside the socialist country. Since then I've made two other trips to Cuba.

The Games were held in Holguin, on the eastern end of the island. After they ended, I flew with the teams on a single charter plane back to Havana. It was well after midnight when we touched down and sections of Havana were blacked out, the electrical quota exhausted for the day. The family of Omar Linares, the legendary third baseman of Team Cuba, met him outside the terminal. Despite the hour, Linares and several of his team-mates weren't rushing to go home. Fans and family clustered around as Linares sat on the hood of his ancient Chevrolet and talked about the series

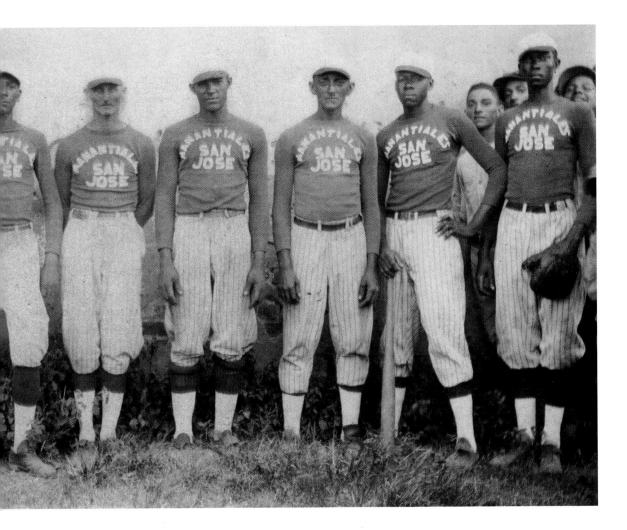

in which Team Cuba had handily defeated the U.S. Olympians.

As I eavesdropped, I couldn't help but think that this is how it used to be—the world of professional sports before the entourages of agents and handlers, stretch limousines and private jets appeared. In some parts of Latin America, families still walk to the ballpark on Sundays dressed in their best clothes after a morning at church. Baseball and community, the game and faith, remain as intertwined as they were in Mays's day.

In 1878, Cuba played host to the first league game in the Caribbean. Some people have wrongly assumed that Americans brought baseball to Cuba; this is false. Nemesio Guillo, a Cuban who studied in the United States, was the person who introduced baseball to his countrymen. Guillo and his brother, Ernesto, founded the Havana Base Ball Club and the game

in Cuba rapidly gained popularity. The first bona fide ballpark was erected in 1874 in Matanzas, east of Havana. Rafael Almeida and Armando Marsans were the first Cubans to play in the major leagues, after being purchased by the Cincinnati Reds from a minor league club in 1911. Amateur leagues flourished around the island's sugar mills—a tradition that would later be duplicated to great success in the Dominican Republic. From Cuba, the game of baseball rippled throughout Latin America. It was like the Cubans had dropped a pebble in a pond and over time the subsequent waves reached all the way down to South America.

"Baseball isn't an easy game to play," explains Orlando Cepeda, a Hall of Fame ballplayer from Puerto Rico, "and in a way that appeals to us Latins. You have to work hard to play the game right. As baseball spread I think that's why it found a home in so many places. It may be difficult to play but when it's done right, it's easy to become passionate about it."

Soon after that first game was played in Havana, Cuban teams began playing against traveling squads from the United States. A quality winter ball league, with such legendary teams as the Habana Leones, Almendares Blues, Marianao Tigres and Cienfuegos Elephants, drew enthusiastic and faithful fans. Latino ballplayers participated and then began to star in the U.S. major leagues.

Adolfo "Dolf" Luque, a fiery right-hander from Havana, became a star in Cincinnati, consistently winning in double figures. In 1923, he went 27-8 for the Reds with a league-best 1.93 ERA. During the 1933 World Series, he pitched $4\frac{1}{3}$ innings of scoreless relief.

Luque "was a snarling, vulgar, cursing, aggressive pug, who though small at five-seven, was always ready to fight," writes Roberto Gonzalez Echevarria in *The Pride of Havana: A History of Cuban Baseball*. "He was known as a headhunter, who mastered the art of pitching close to the batter (something he taught to others of his ilk, such as Sal Maglie)."

Echevarria details how Luque was subjected to jeers and insults from opposing dugouts during his twenty-year major league career. Instead of turning the other cheek, he often retaliated. He once charged the New York Giants dugout and punched Casey Stengel, then a journeyman outfielder. In the U.S., Luque was known as "The Pride of Havana" or the "Havana Perfecto." But in his native country he was better known as "Papa Montero"

DIHIGO AND LUQUE TOGETHER

Martin Dihigo, manager of the Cienfuegos Baseball Club, far left, argues with Adolfo Luque (32), manager of Habana, and the umpire during a game at Tropical Stadium.

HAVANA, CUBA
1940

after a legendary Afro-Cuban rumba dancer. Luque remained loyal to his homeland, pitching winter ball in Cuba. Eventually he followed Stengel into the managing ranks. While Stengel became known as "The Old Professor" as the skipper for the New York Yankees and Mets, Luque managed in Cuba and Mexico. Still, Luque didn't mellow much over the years. Several times he threatened his malingering players with a handgun.

In fits and starts, the Latino market became known to the rest of the

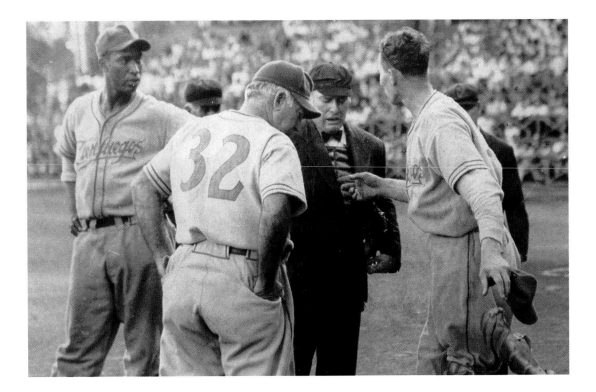

baseball world. Papa Joe Cambria was regarded as the region's first super scout. Even though he was fluent in Italian, rather than Spanish, Cambria was adept at finding cheap talent, often signing players to blank contracts in the countryside outside of Havana. He convinced Clark Griffith, owner of the Washington Senators, to make him the ballclub's Latin American scout, and Cambria went on to send a half-dozen Cuban pitchers to the Senators. A myth still persists that in the 1940s he scouted Fidel Castro but this has since been disproven by baseball historians.

A 1989 article in *Harper's* magazine cited four scouting reports on Castro. According to the story, Cambria was impressed with the right-hander. "Fidel Castro is a big, powerful young man," Cambria reportedly said. "His fastball is not great, but passable. He uses good curve variety. He uses his head and can win that way for us, too."

Alejandro Pompez, a bilingual scout from the U.S., followed in Cambria's footsteps and reportedly offered Castro a $5,000 signing bonus. He was stunned when the future revolutionary turned him down. More importantly for the development of Cuban baseball, Pompez sponsored quality teams. His New York Cubans (based in New York), according to Echevarria, "became not just a team of Cubans but also of Latins (some of them white) from various countries as well as American black players."

Luque and other early Latino pioneers only found a place at baseball's top levels because they were deemed light-skinned. Before Jackie Robinson broke the color barrier in 1947, players from the Caribbean were as restricted by race and color lines as the stars from the old Negro Leagues were. For example, Martin Dihigo was a top Cuban ballplayer, but he never got a chance to play in the majors. Like many Latino players from his era, Dihigo was relegated to a step below the U.S. major leagues because of the color of his skin.

Dihigo was born in 1905 in Matanzas, Cuba, where the island's first ballpark had been built. He made his Negro Leagues debut at the age of 17 and soon demonstrated that he could play any position as the great Babe Ruth did. Dihigo's lifetime pitching record was reportedly 256-136, and the games where he went against Satchel Paige were legendary. A right-hander, Dihigo threw no-hitters in at least three leagues outside of the U.S. major leagues—Mexico, Puerto Rico and Venezuela. In addition, Dihigo reportedly won three home run titles while playing for the Homestead Grays and tied Josh Gibson for a fourth.

Walter "Buck" Leonard, who played against him in the Negro League, says Dihigo "could run, hit, throw, think, pitch and manage. You

Opposite:

CIENFUEGOS BASEBALL CLUB

Negro League catcher Ray Noble of the Cienfuegos team tags a Havana Lions player during a game at Tropical Stadium.

HAVANA, CUBA

1950

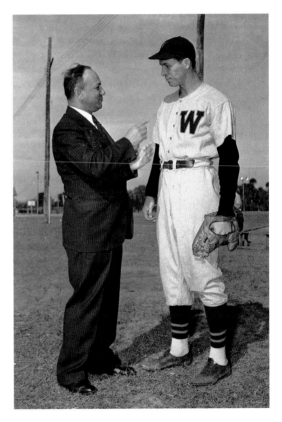

Above:

SCOUTING

Joe Cambria, the scout for the Washington Senators, left, talks with pitcher Roberto Ortiz at the Senators' rookie camp.

ORLANDO, FLORIDA

1939

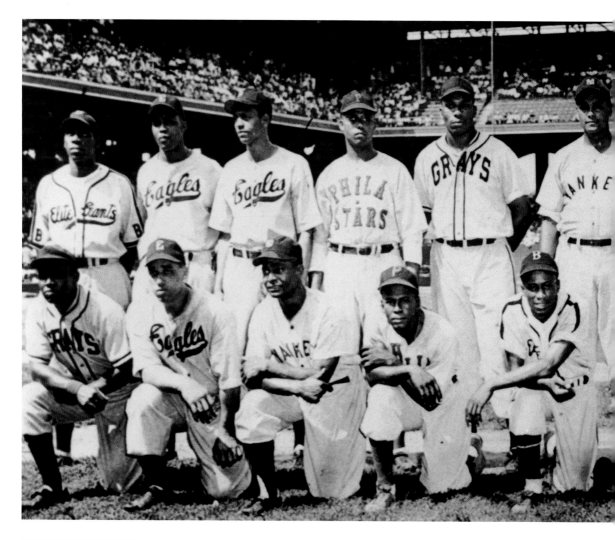

**THE NEGRO LEAGUE EAST
ALL-STARS TEAM**

The East Team poses before the
East vs. West game. They lost
3-0. *Front row (L-R)* Buck Leonard,
Bob Harvey, Marvin Barker, Frank
Austin, Pee Wee Butts, Orestes
Miñoso, Luis Marquez, Louis
Louden, Bob Romby, Jim Gilliam.
Back row (L-R) Lester Lockett,
Monte Irvin, Rufus Lewis, Henry
Miller, Luke Easter, Robert
Griffith, Pat Scantlebury, Wilmer
Fields, Bill Cash, coach Vic Harris
and manager Jose Fernandez.

CHICAGO, ILLINOIS **1948**

can take your Ruths, Cobbs and DiMaggios. Give me Dihigo. I bet I would
beat you almost every time." Dihigo was eventually enshrined in four
baseball Halls of Fame—in Cuba, in Venezuela, in Mexico and in
Cooperstown, N.Y.

At six-one and 190 pounds, Dihigo was a prototypical player of the
modern era. Imagine a Vladimir Guerrero or Alex Rodriguez who could
pitch, too. That's what Dihigo was. Unfortunately, much of the baseball
world never got a chance to see him play or cheer his accomplishments.
His baseball card would have gaps and incomplete lines for pitching and
batting as records in the old Negro Leagues were spotty at best, and some-
times Dihigo would play in other countries because the money was better.

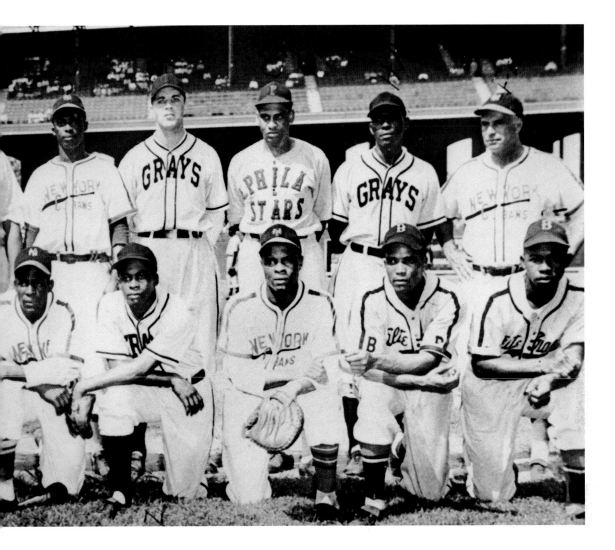

"For versatility on the baseball diamond, Martin Dihigo was in a class by himself," reads a scouting report at the National Baseball Hall of Fame and Museum in Cooperstown, New York. "He was also a power hitter who possessed one of the strongest arms in black baseball."

Early in his career, Dihigo played shortstop or second base. But he soon began to pitch and play the outfield too. Published figures credit him with batting averages of .408 in 1927, .386 in 1929 and .372 in 1935. After 1936, Dihigo played mostly in Mexico. There he topped all pitchers with a 0.90 ERA. Not only did he pitch a no-hitter south of the border in 1937, but he had six hits in single game in 1939.

"In an era when a handful of light-complexioned Latins (notably Dolf

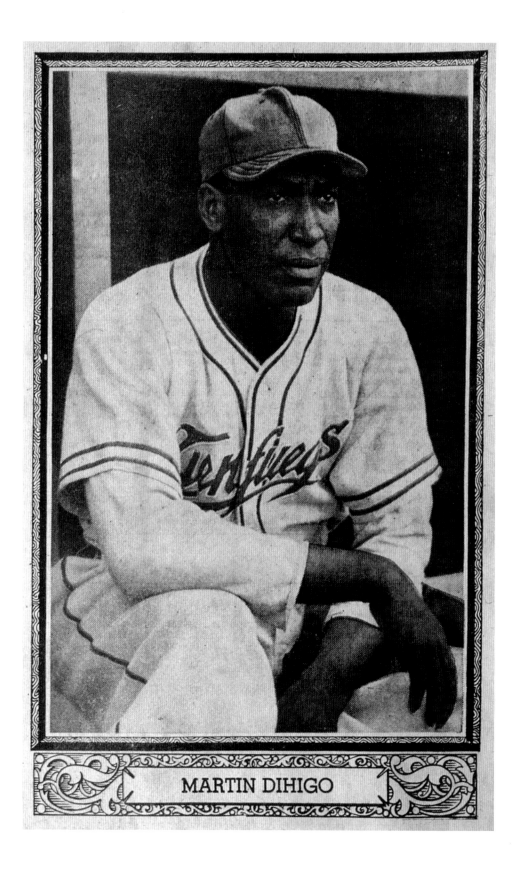

MARTIN DIHIGO

Luque and Mike Gonzalez) made it to the majors, black Cubans played out their careers for the Cuban Stars and the New York Cubans of the Eastern Colored and Negro National Leagues," another Cooperstown report reads. "To his early day black contemporaries, Dihigo was the greatest professional baseball player. To sports fans today, he is an unknown."

After his playing days were over, Dihigo stayed in Cuba. He became an announcer in Havana and often held court, talking baseball. He was elected into the Hall of Fame in Cooperstown in 1977, six years after his death.

Growing up, Orestes Miñoso idolized Dihigo. Both of them hailed from Cuba and early on it appeared that Miñoso would also share Dihigo's fate of being too dark-skinned to play in the U.S. major leagues. But that changed when Jackie Robinson took the field for the Brooklyn Dodgers in 1947. Robinson averaged .311 at the plate during his ten seasons in the majors and often drove opponents to distraction with his speed on the base paths. Again, we often view such landmark events solely from an American perspective. But Robinson breaking the color barrier also opened up the game to many players from other lands. If they had the courage, they could follow in Robinson's footsteps. One who immediately stepped up to the plate was Miñoso.

He began with the Cleveland Indians in 1949 but soon after Miñoso was traded to the Chicago White Sox. He soon became a crowd favorite among residents of Chicago's South Side and an integral member of the White Sox. More important, he was arguably the city's first black superstar. Decades later, Miñoso remains as beloved as such Chicago sports legends as hockey's Stan Mikita and basketball's Michael Jordan.

Luis Tiant, who pitched 19 seasons in the major leagues and broke Luque's record for most victories by a Cuban-born hurler, says that Miñoso "was my idol growing up. He was the first one to stand up for black Cubans. Guys like me. You see somebody like that make it and you have some hope. You start to believe that maybe one day you can reach the big leagues, too."

Orlando Cepeda adds that Miñoso "is to Latin ballplayers what Jackie Robinson is to U.S. black ballplayers."

A seven-time All-Star, Miñoso ushered in the first wave of Latino stars at the big-league level. While playing for the White Sox, he joined with

MARTIN DIHIGO

The *Sensacion* newspaper issued a special premium baseball trading card of baseball star Martin Dihigo.

HAVANA, CUBA
1936

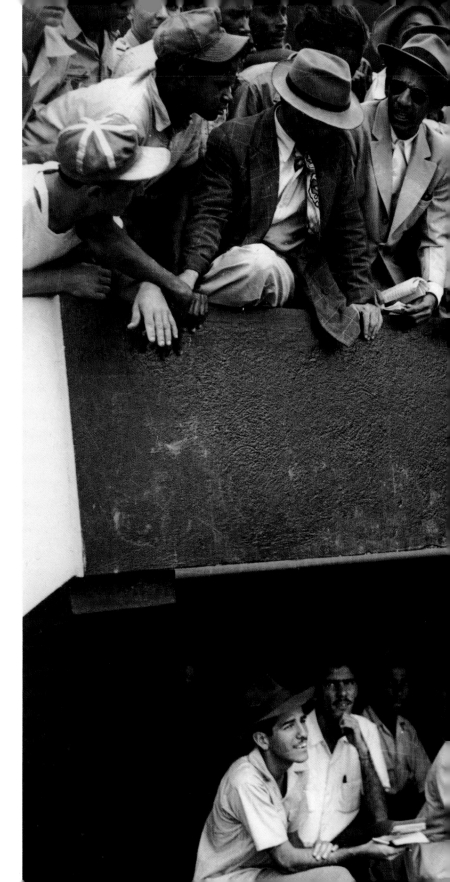

BREAKING THE BARRIER

Just weeks after this photograph was taken during spring training in Cuba, Jackie Robinson of the Brooklyn Dodgers would play a major league game with his white teammates for the first time. His stellar performance opened the door for other Latino and African-American players in the U.S. and elsewhere to have a chance to play in the major leagues.

HAVANA, CUBA
1947

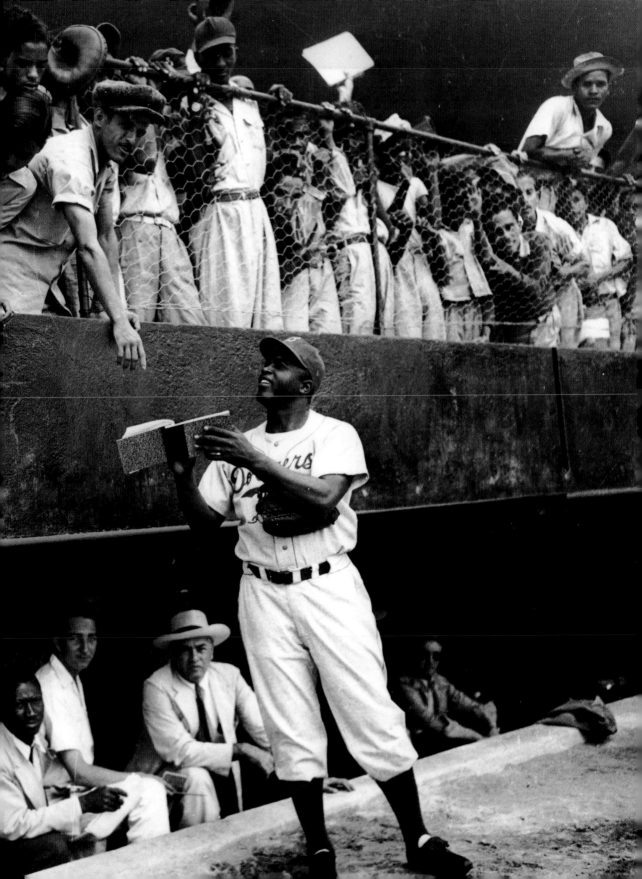

Alfonso "Chico" Carrasquel, the slick-fielding shortstop from Venezuela. Carrasquel began a long line of All-Star shortstops from that country that would eventually include Luis Aparicio, Dave Concepcion, Ozzie Guillen and Omar Vizquel. A few years after Miñoso broke in, Cepeda and Roberto Clemente arrived from Puerto Rico and the Alou brothers from the Dominican Republic.

"I never let the world hurt me," Miñoso says. "The world didn't break me. They used to call me terrible things. I let it go in one ear and out the other. None of it stayed with me. I never wanted them to know my feelings on the inside. On the outside, I just gave them my smile. My smile all the time."

Miñoso's stories about the racial prejudice he faced are similar to what such African-American athletes as Hank Aaron and Willie Mays had to endure. Early on, Miñoso said the legendary Ted Williams told him to be strong, especially in a batting slump.

"This is what the world is like, my friend," Miñoso adds. "You cannot let anyone run your life because they call you names or tell you that you can't play. When I played I sometimes had to play the clown. I had to listen and laugh, even though I was crying inside. But never did I let them see that it bothered me.

"I tried to answer with my bat. Always my bat. It's like if you're a singer. If you hear noises out there, people may not like how you're singing, are you going to stop and tell them to be quiet? Of course not. You keep singing."

Yet to sing, to play with flair and abandon, wasn't easy at first. When Clemente arrived in this country, he was more outspoken than Miñoso about the Jim Crow laws and the racism he encountered. He said being a Latino ballplayer was to live as "a double minority"—singled out for being black and unable to speak the language.

When Clemente first reported to spring training camp for the Pittsburgh Pirates in 1955, he was soon labeled as a "hot dog" by the local press. When he spoke, the reporters quoted him phonetically in the newspaper. "This" became "Theez" and "Hit" became "Heet" in the

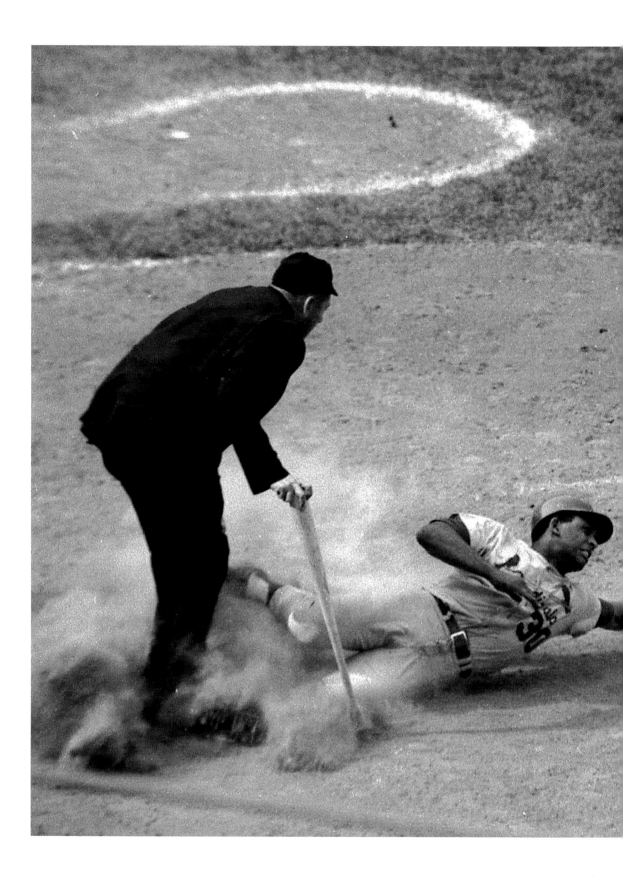

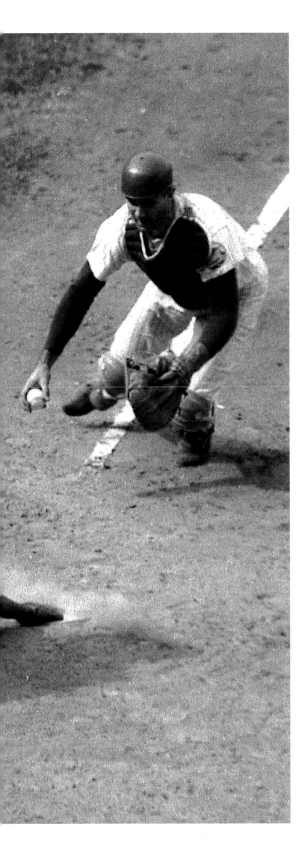

Opposite:

IT'S BETTER IN ST. LOUIS

Orlando Cepeda, first baseman
for the St. Louis Cardinals,
scores as Mets catcher J. C.
Martin fails to tag him.

SHEA STADIUM, NEW YORK
1968

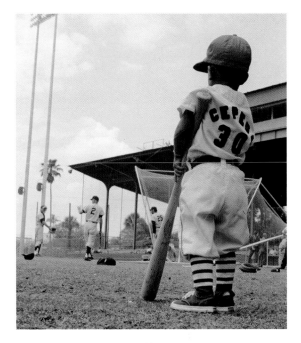

Above:

ALL IN THE FAMILY

Orlando Cepeda Jr., the two-
year-old son of the first baseman,
is in uniform with the New York
Yankees in the background at
batting practice.

1968

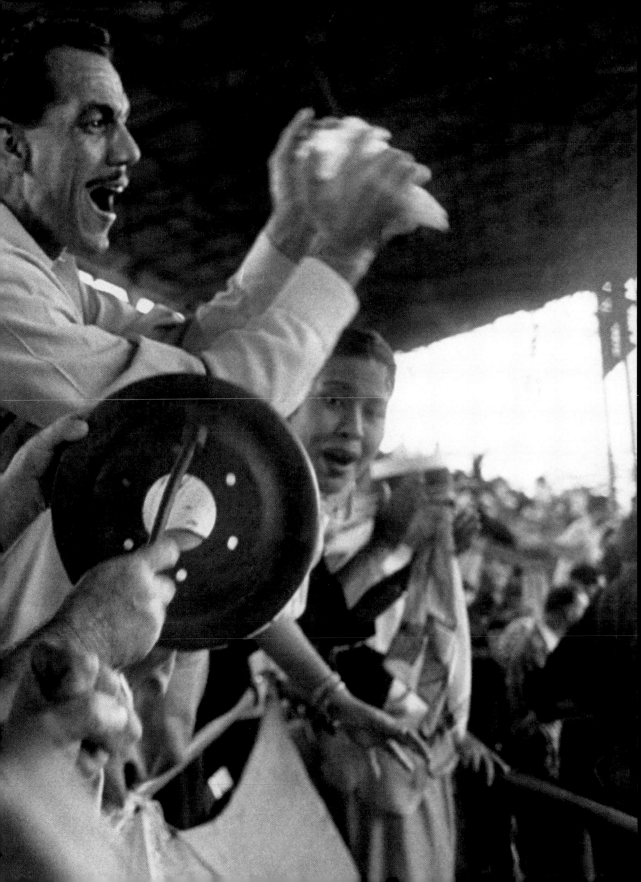

news copy. Clemente soon decided that the press was simply out to embarrass him.

A generation ago, Latino players like Clemente and Cepeda were similar to seasonal migrant workers. During the season they earned good money in the United States but during the off-season they returned home where they could reconnect with their friends and their family as well as their culture. To stay in shape they would play for their winter teams like Santurce or Licey. But, more important, many of the players would have to find ways to recover their pride after being treated rudely in the U.S. big leagues.

After the 1960 World Series, for example, Clemente couldn't wait to return to his native Puerto Rico even though his team, the Pittsburgh Pirates, had won the Series. While Clemente hit .314 with 16 home runs and collected 19 outfield assists during the season, he only finished eighth in the National League's Most Valuable Player balloting. He had been overshadowed-at least in the local newspapers—by white teammates Dick Groat and Don Hoak.

"Roberto was as valuable as either of them," Bill Mazeroski, another Pirates teammate, would say years later. "It affected him as a person and made him bitter."

But the time back home helped steel Clemente for the following season. In 1961, he hit .351 to lead the senior circuit.

Orlando Cepeda, Clemente's countryman, was soon a victim of similar circumstances and misunderstandings. He had broken into the majors in 1958 and was named Rookie of the Year, leading the league in doubles. Born in Ponce, Puerto Rico, Cepeda was nicknamed "Cha-Cha" for his love of salsa music and "Baby Bull" for his family's baseball legacy. His father was Perucho "The Bull" Cepeda—the Babe Ruth of Puerto Rico.

"Nobody was as good as my father," Cepeda says. "I never came close."

In his day, the elder Cepeda swung an R43 baseball bat. That's the same model that Ruth first popularized. In San Francisco, Cepeda teamed up with Willie Mays to form one of the best one-two punches at the plate in the game. Together they hit 552 home runs—the same number as Hank Aaron and Eddie Mathews did for the Braves over the same time frame.

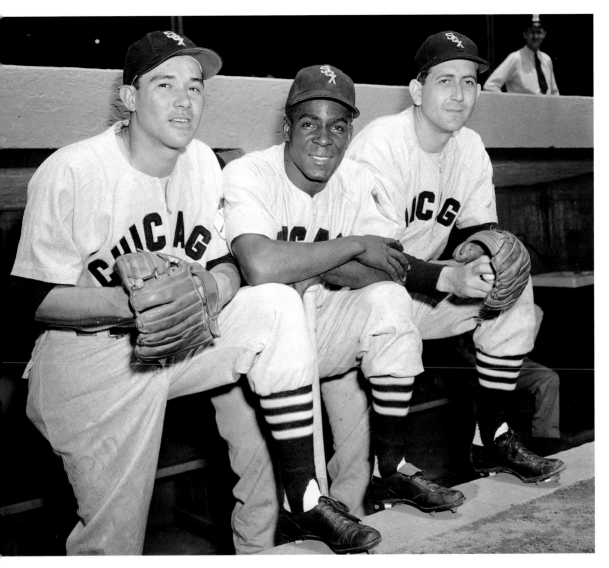

CAMARADERIE

Three of the early Latino stars played for the Chicago White Sox. From left to right, shortstop Alfonso "Chico" Carrasquel, out-fielder Orestes "Minnie" Miñoso and pitcher Luis Aloma.

1951

While the Bay Area fans embraced Cepeda, he had tumultuous relationships with Giants manager Alvin Dark and his successor, Herman Franks. Decades later, Cepeda says that Dark made his life "a living hell. Things would go so bad at times that there were days I didn't want to go to the ballpark."

In the end, neither man let the emotional abuse deter them. After the 1961 season, Clemente and Cepeda rode in a Cadillac convertible through the streets of San Juan, Puerto Rico. At that moment, they were among the best players in baseball. Between them, they had captured the

LUIS APARICIO

One of the top shortstops from Venezuela, Luis Aparicio played for 18 years in the major leagues and was inducted into the Hall of Fame in 1984.

1956

National League Triple Crown. Clemente had led the league with his .351 batting average, while Cepeda had hit 46 home runs and 142 RBIs—a San Francisco Giants record.

"Those are the times you live for," Cepeda says. "You wish you could stop everything and live with that forever. But, of course, it doesn't work that way."

In the 1960s, a clash of cultures began within baseball. Once Felipe Alou, Cepeda's teammate, struck out four times in a game. That's called "a golden sombrero" in some circles. As Alou returned to the dugout, his Latino friends teased him in Spanish in an attempt to get him to forget a bad day at the office and look forward to tomorrow's game. But such actions were misunderstood by the team's American members. The edict

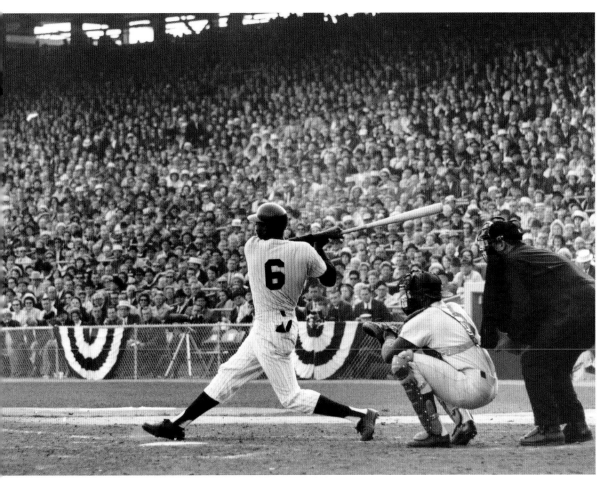

TONY OLIVA

Minnesota Twins player Tony Oliva at bat during a World Series game against the Los Angeles Dodgers.

BLOOMINGTON, MINNESOTA
1965

came down from the manager's office—the Spanish language was prohibited from being spoken in the Giants' clubhouse or dugout.

Turmoil within the game was brewing elsewhere, too. Even though Fidel Castro played baseball growing up, his embrace of communism as prime minister of Cuba during the cold war period signaled trouble for Cuban professional ballplayers. Cuba was the top exporter of baseball talent to the U.S. major leagues at that time. Later, Castro would be the unofficial general manager of the national team. But his political views helped sever the relationship between the U.S. and Cuba.

Miñoso and other top Cuban players of that era—Tony Oliva, Jose Cardenal and Luis Tiant—were forced to leave their homeland permanently.

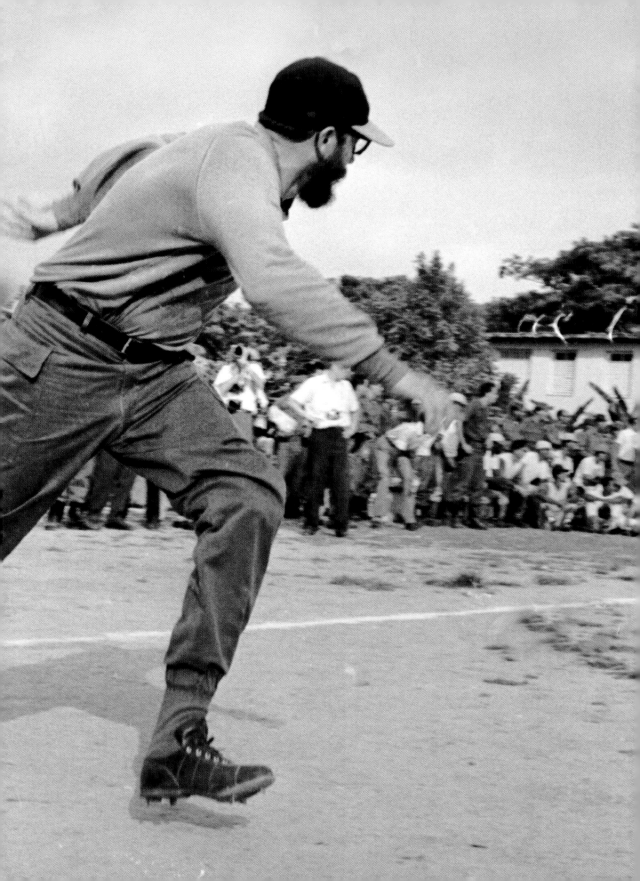

Many found a new home in the U.S. major leagues only by chance. Major league teams began to look for another place to develop players in the Caribbean. That eventually led to the Dominican Republic becoming a baseball power.

George Genovese, who had been scouted by Joe Cambria as a 16-year-old shortstop and would go on to become one of the top scouts of the modern era, was managing the minor league team for the San Francisco Giants in El Paso when relations between the U.S. and Cuba froze. On his roster was Jose Cardenal, another Cuban player from Matanzas. Cardenal was listed as an infielder and hadn't achieved much during spring training. The Giants had decided to release him. That decision would have probably sent Cardenal back to Cuba for good. But Genovese argued to keep the young Cuban stateside. Team officials relented and Genovese moved Cardenal to the outfield. Cardenal hit a homer in his first game for El Paso. Cardenal went on to play for 18 years in the major leagues.

"Sometimes you have to realize what people on your team are really up against," Genovese says. "I couldn't imagine living with myself if Cardenal had been sent back to Cuba on my watch."

Occasionally, a legitimate baseball prospect will still escape the island. Cuban defector Livan Hernandez won the Most Valuable Player award for the 1997 World Series. Soon afterward, his half-brother, Orlando "El Duque" Hernandez fled, too, and posted a remarkable record in postseason play. Yet they remain the exceptions. Thanks to Castro and the decades-long dysfunctional relationship between Cuba and the U.S., few have been afforded the opportunity to play in the major leagues.

But baseball still reigns in Cuba. On any given day in Havana, baseball fans gather to talk baseball in the Parque Central. Welcome to *esquina caliente*—the hot corner. On a 1997 visit there I was accompanied by Milton Jamail, an expert on Latino baseball and the author of *Full Count: Inside Cuban Baseball*. Under the royal palm trees, groups were debating all issues of baseball, from last night's local action to what was going on in the major leagues. Even though Cubans have little access to the Internet, radio or televised highlights on ESPN, they stay abreast of big league games, often by word of mouth. Box scores are copied by hand and passed around. When

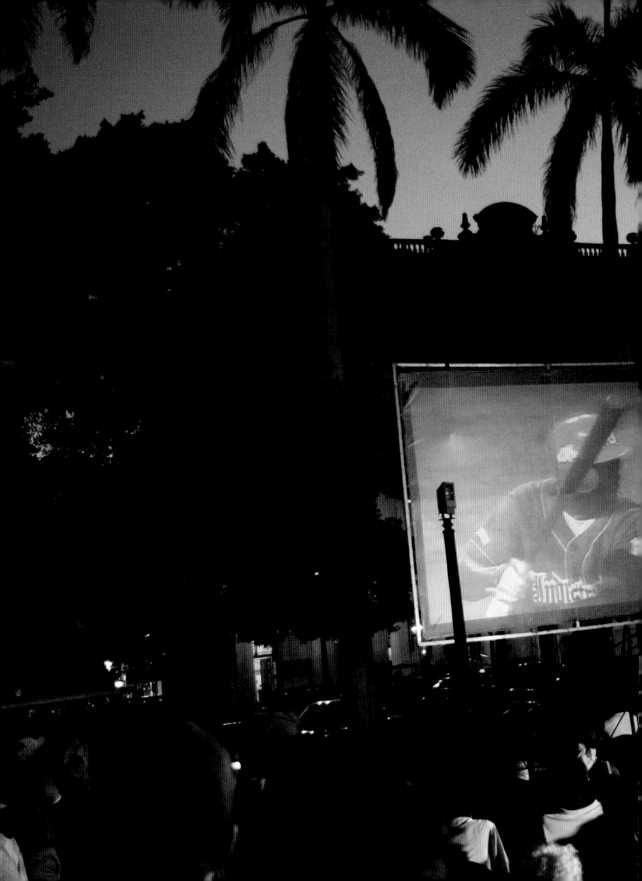

SURVIVAL OF THE FITTEST

Cuban-born Jose Cardenal, a cousin of Bert Campaneris, saved his career by shifting his position to the outfield. He went on to play for 9 teams during 18 years.

CIRCA 1965-67

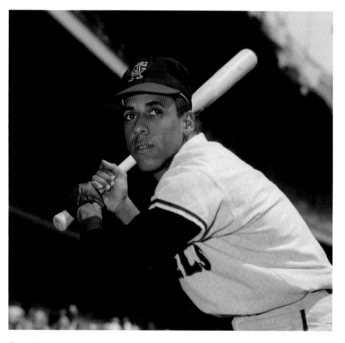

Opposite:

ONE WHO GOT AWAY

Florida Marlins pitcher Livan Hernandez was named the Most Valuable Player during the World Series two years after he defected from Cuba.

MIAMI, FLORIDA

1997

I go to Cuba I often bring along copies of American sports publications and hand them out. Fans there know the names, teams and statistics but they rarely recognize the faces. "Is that what Mark McGwire really looks like?" a fan in Havana once asked me.

On this visit to *esquina caliente*, a group of argumentative fans surrounded Milton and me. One of them asked how we felt about professionals playing in the Olympics. I responded, "Let the best play against the best."

My comment was met with frowns and silence.

"Do you believe the Cuban national team is really challenged by the level of competition it plays?" we were finally asked.

Milton and I said no. Heads nodded all around.

Perhaps that's the best reason why so many come from outside our borders to play in the U.S. major leagues: to play against the best. Too often we assume everything is about the money, the chance to land a big contract.

That's something the Baltimore Orioles didn't understand when they played a home-and-away exhibition series against Team Cuba in 1999. The major leaguers couldn't understand why the Cubans ran the base paths like crazy men, pulled their starting pitcher after he struggled early in the game. Years later at the inaugural World Baseball Classic, the players from the U.S. major leagues again looked sluggish while teams from Japan, Mexico and Cuba played with passion.

"I've waited all my life to be here, to play baseball in a place like this," Omar Linares said before the final exhibition game at Camden Yards in Baltimore. He had just posed for photographers next to Oriole Hall of Famer Cal Ripken. "It's taken a long time to reach this."

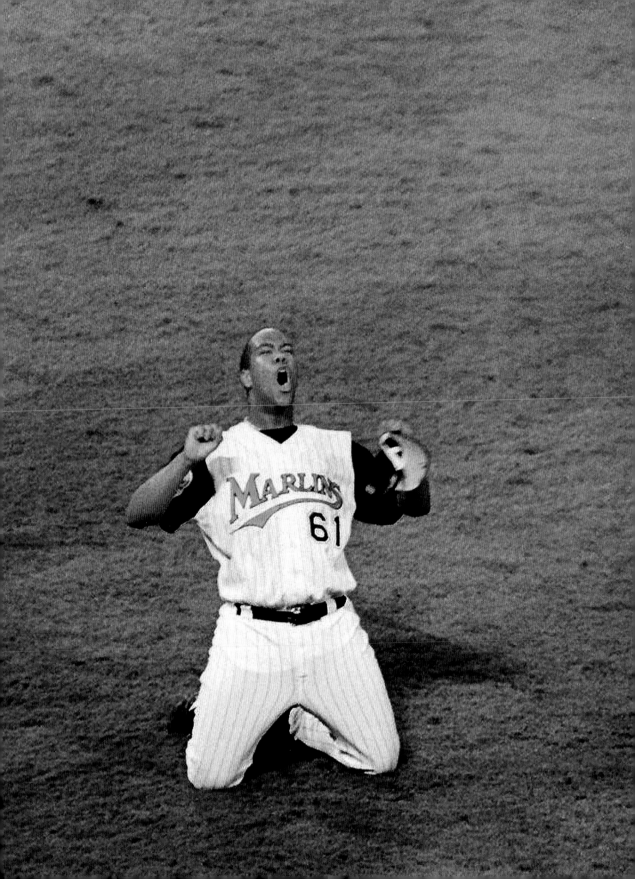

THE CRY OF CUBA

S. L. PRICE

Senior Writer, *Sports Illustrated,* and author of *Pitching Around Fidel: A Journey into the Heart of Cuban Sports* and *Far Afield, A Sportswriting Odyssey*

EVENT PLANNING
Fans of all ages filled the Hiram Bithorn Stadium on March 12, 2006, to watch Cuba play Venezuela in the first World Baseball Classic tournament.

SAN JUAN, PUERTO RICO
2006

What is the Cuban game? *For norteamericanos,* **it's a baseball distilled to** flamboyant flashes of personality: Luis Tiant's corkscrew windup, Jose Canseco flexing a bicep as a crowd chants "Steroids!," Orlando "El Duque" Hernandez bringing his left knee up so high before each pitch that he seems sure to knock out his own teeth. The physical charisma becomes so mesmerizing sometimes that you forget the score, and find yourself debating whether it's merely a tic or the bubbling up of true character. In a stadium in the Bronx or Oakland, you can even argue that this is all somehow a manifestation, the cry of Cuba itself.

But that's an illusion. To know Cuban baseball you have to have sat in the provincial stadium outside Havana and watched the fans passing white rum in old plastic bottles and heard the drums and bells and air-raid siren winding up as the Industriales began another rally at *Latinoamericano,* outfield signs declaring "Cuba! Land of Courage and Tenderness!" You have to have happened upon the early-afternoon quiet at Santiago's Moncada Stadium to find the longtime captain of the Cuban national team, second baseman Antonio Pacheco, alone and frogwalking his way up the first baseline to get his aging body back in shape. You have to have spoken not just to those who braved the killer waters of the Florida Straits to get away, but to those who endured the brutal rigidity of the Castro regime.

And somewhere in all that you'll discover that Cuba's national pastime never surrendered itself to politics. Not completely. Indeed, what distinguishes the Cuban game from that of its Caribbean and Latino counterparts is precisely the tension that exists between a regime intent on using baseball for its own ends and a cultural treasure that best shows the black humor and untameable spirit, the intelligence and sadness that lies at the heart of modern Cuban life. Of course all players are monitored, and the best militantes—Communist party stalwarts—get preferential treatment, fine homes, and foreign travel. Those with questionable attitudes—no matter how talented—have no shot at playing for the national team.

Pacheco's loyalty to the regime is a tough, unyielding thing. But it's instructive to know that even he rooted for Cubans who went on to play for the Yanqui dollar. "I'd be lying to say I wasn't proud of him," Pacheco said once of El Duque's exploits with the New York Yankees. "He's showing the world Cuban baseball." Loyalty to teammates—to the game—is a quality prized above ideological purity. The Cuban bond is a stirring mix of dominance and loss.

Winning has proven to be the easy part. For forty years, Cuba's national team has been one of the great dynasties, an institution that has outlasted the fall of the Berlin Wall and the rise of Nixon, Reagan and Bush, father

and son. Cuba, the three-time Olympic champion, has reached the final or won every major international tournament it has entered since 1959, and at one point during the 1980s and 1990s ran off an astonishing 152 victories in a row. There have been some losses: the 2000 Olympic final to the U.S.A., and the final of the 2006 World Baseball Classic to Japan. But after losing to Japan in the '97 Intercontinental Cup, pitcher Pedro Luis Lazo summed up the usual Cuban attitude after such setbacks. "There's no doubt we're going to win," Lazo laughed then. "And win and win and win."

So they have. In the summer of 2007, Cuba won its tenth straight

Pan Am Games title. Pacheco is long retired now, but Lazo, at somewhere north of 35, proved to be another in a long line of Cuba's ageless warriors, serving as the team's dominant closer and shutting down the U.S.A. in the final to seal the 3-1 victory. Few outside the island noticed. It's true that the victory came in summer, when the best Americans and Dominicans and Venezuelans are off playing in cooler climes. And it's true, too, that in Cuba baseball is king partly because, in the modern world, it benefits from insularity. With little of the distractions afforded in the capitalistic cultures, baseball in Cuba offers rewards few other professions can.

But for those who have seen it close, the paradox that lies at the heart of the Cuban game is part of its irresistible appeal. Its success exists as a result of Fidel Castro's revolution, and exists in spite of it, too. No one has done more to craft, support and control Cuba's baseball dynasty than the one time pitcher turned comandante, and his demise will signal the beginning of an end. Cuba's dominance will fade some, as more players slip loose to the lights and money waiting up north. But it can never fully die. More than politics, more than any part of the system, the Cuban game belongs to the people. They will never let it go.

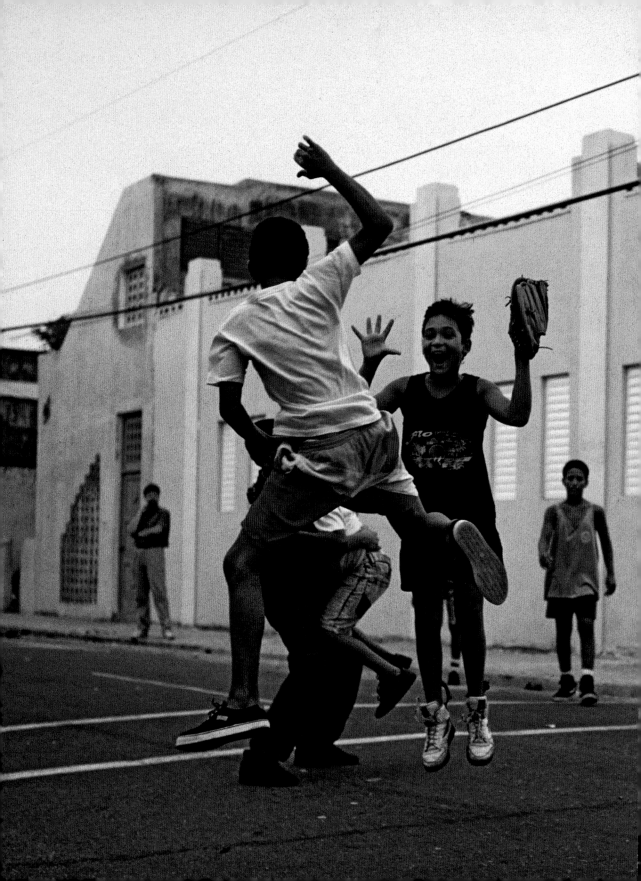

SECOND BASE

THE GOLDEN ERA

THE GOLDEN ERA:

By the 1960s, Caribbean and South American nations already had more players reach the U.S. major leagues than Germany, England and Canada. Arguably, there were more Latino stars than their European and Canadian counterparts: Orestes "Minnie" Miñoso, Chico Carrasquel, Luis Aparicio and the Alou brothers, to name a few.

With the closing of Cuba, the number of ballplayers from Mexico, Panama, Nicaragua and Venezuela began to soar. One of the players caught in the middle of the transition was Tony Oliva. While the U.S. and Cuba faced off during the Bay of Pigs in 1961, Oliva was in danger of losing his place playing for the minor leagues. All flights to Cuba had been canceled. With nowhere to send him, the managers of the Twins decided to keep Oliva, who three years later would become the first rookie in major league history to win a batting championship. Like the story of Jose Cardenal, Oliva was able to turn his professional career around because of his inability to return home.

On other teams the welcome was not so warm. The San Francisco Giants declared the Spanish language off-limits in the dugout and in the clubhouse. Other organizations regarded Latinos as hot dogs or show-offs. First baseman Victor Power was a victim of such stereotyping.

Early in his career, the dark-skinned Puerto Rican languished in the New York Yankees' farm system. Even though he led the American Association in hitting and was a budding defensive star at first base, the most successful sports franchise in U.S. history was reluctant to bring Power up to the big leagues. According to Peter Golenbock, author of *Dynasty: The New York Yankees, 1949–1964,* the Yankees considered Power a showboat, partially because of his flair for catching throws to first base with only his glove hand. A generation ago, most players caught the ball with their glove and then quickly secured it with their bare hand.

In stretching to retrieve tosses with only his glove, Power revolutionized the position. Any first baseman playing today is essentially following Power's example. Once a sportswriter asked Power why he insisted on catching the ball with one hand when everybody else was still using two hands. "If the guy who invented baseball wanted us to catch with two hands," Power replied, "he would have invented two gloves."

After the Yankees rejected him, Power began his major league career with the Philadelphia Athletics in 1954. He was soon traded to Kansas City

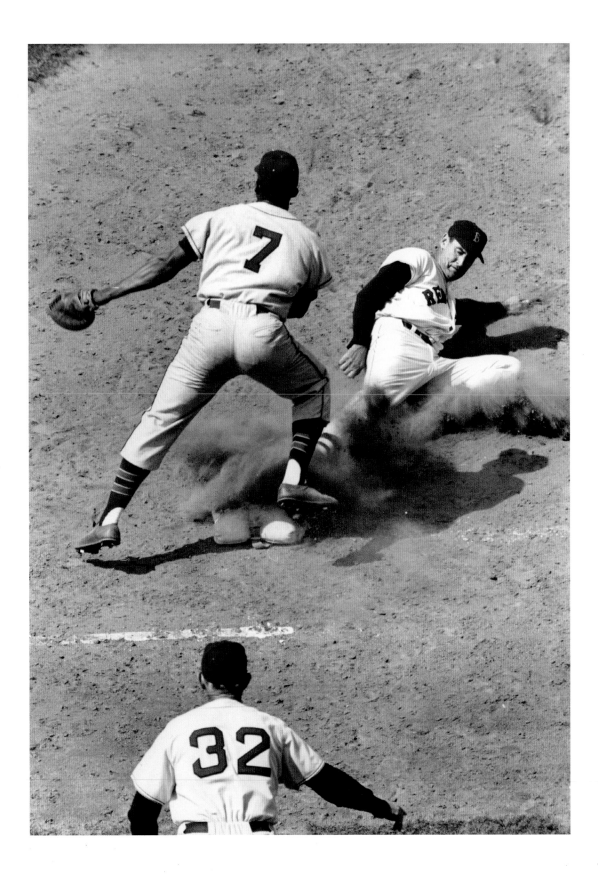

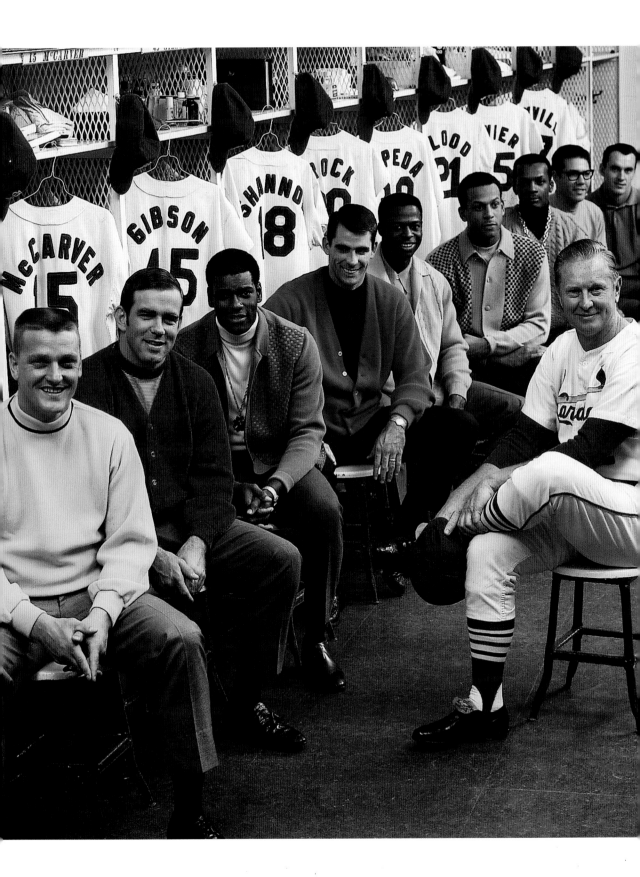

and then to Cleveland during the 1958 season. With the Indians he won four Gold Glove awards and was named to the All-Star team twice.

"Before there was Albert Pujols, there was Power," writes Jesse Sanchez of MLB.com. "Before Rafael Palmeiro, Tony Perez and Orlando Cepeda, there was Power."

Today, Puerto Rico has been overshadowed by other baseball hotbeds, notably the Dominican Republic and Venezuela, when it comes to producing major league talent. But in the 1960s, many of the top players hailed from Puerto Rico. And even though it has been a U.S. territory since the Spanish-American War, the players from Puerto Rico did not receive any better treatment in the U.S. than their Latino brethren.

While Power was criticized for revolutionizing how a position was played, Orlando Cepeda was traded away from his adopted city, San Francisco, 19 games into the 1966 season. The Giants had tired of his loose mouth and Cepeda had decided he no longer trusted the ball club. A few years earlier he had hurt his knee while lifting weights. Fearful of how management would react, he kept the accident a secret.

"Because I knew that the team would give me flak, I did not tell a soul other than my wife," Cepeda says. "I was determined not to let Alvin Dark get on my case any more than he already did."

Considered past his prime, Cepeda found a home with the veteran 1967 St. Louis Cardinals ball club. Bob Gibson, Steve Carlton and Nellie Briles headed a deep pitching rotation. Roger Maris, who had broken the single-season home run record a half-dozen years earlier with the New York Yankees, was in right field, with base-stealing threat Lou Brock in left. Tim McCarver, who went on to become a national television analyst, was behind the plate. Julian Javier from the Dominican Republic was at second base.

"That team was a group of guys who knew how to get along," Briles remembers. "Orlando had no problem fitting in with us."

The Cardinals finished the season ten and a half games ahead of the second-place Giants, Cepeda's old team, and defeated the Boston Red Sox in the World Series. "That's as satisfying a season as I ever had as a player," Cepeda says.

The same season Cepeda found redemption in St. Louis, Rod Carew, a young second baseman from the Canal Zone in Panama, broke in with the

THE WINNING TEAM

Soon after leaving San Francisco, Orlando Cepeda, whose nickname was "Baby Bull," helped the St. Louis Cardinals to win the World Series. L-R: Roger Maris (9), Tim McCarver (15), Bob Gibson (45), Mike Shannon (18), Lou Brock (20), Orlando Cepeda (30), Curt Flood (21), Julian Javier (25), Dal Maxvill (27), and manager Red Schoendienst in locker room.
ST. LOUIS, MISSOURI
1968

Minnesota Twins. He would later flirt with hitting .400 in a season, but not before he and many in baseball were riveted by the closing chapters of Roberto Clemente's life.

Before the 1971 season, Briles was traded along with Vic Davalillo from St. Louis to Pittsburgh for Matty Alou and George Burnet. A journeyman pitcher, Briles thought nothing could top winning the championship four years earlier with the Cardinals. Bob Gibson won three games against Boston, but what's often forgotten is that Briles held the Red Sox to seven hits in winning the pivotal Game Three.

"I thought I'd seen it all, experienced it all," Briles said, "until I got the chance to see Roberto Clemente play every day."

In 1971, the Pirates defeated San Francisco in the National League Championship Series and advanced to the World Series against the favored Baltimore Orioles. Being the underdog didn't bother Clemente. After all, he had marched to his own drummer since breaking in with the Pirates in 1955.

"Whenever I saw Clemente he had a somber, aggrieved air, which seemed to say, 'Why aren't you going to recognize my greatness? Why is it up to me?'" Roy Blount Jr. writes. "He took things so personally, and in such uncommon ways, that people who thought in categories (a category that includes nearly everyone) found him awkward to deal with."

But nobody played the game with as much pride as Clemente. David Maraniss, author of *Clemente: The Passion and Grace of Baseball 's Last Hero,* points out that myth and events became so intertwined with the Pirates star that 42 public schools, 2 hospitals and more than 200 parks and ballfields, from Puerto Rico to Pennsylvania, would one day bear his name.

"In the world of memorabilia, the demand for anything Clemente is second only to Mickey Mantle," Maraniss writes, "and far greater than Willie Mays, Hank Aaron, Juan Marichal, or any other black or Latino player."

The myth turned to public memory during the 1971 World Series as Clemente carried the Pirates to the championship. As the Series MVP, he batted .414 and excelled in the field. By the end of the seven-game series, Baltimore base runners knew better than to test his powerful arm.

"Finally, after all those years," Briles says, "he got the respect he deserved."

Opposite:

STAR POWER

Early in his career, Roberto Clemente didn't receive much attention or even respect. But by the twilight of his career many considered him one of the best right fielders ever. Here, he's pictured on the cover of *Sports Illustrated*.

1967

Following Pages:

THE WINNING TEAM

Roberto Clemente, who played for the Pittsburgh Pirates his entire major league career, soon gained a reputation for acrobatic catches and accurate throws from the outfield.

Sports Illustrated

JULY 3, 1967 40 CENTS

THE BIG HITTERS ARE BACK
IN THE NATIONAL LEAGUE

BILL TERRY 1930 .401

ARKY VAUGHAN 1935 .385

STAN MUSIAL 1948 .376

HENRY AARON 1959 .355

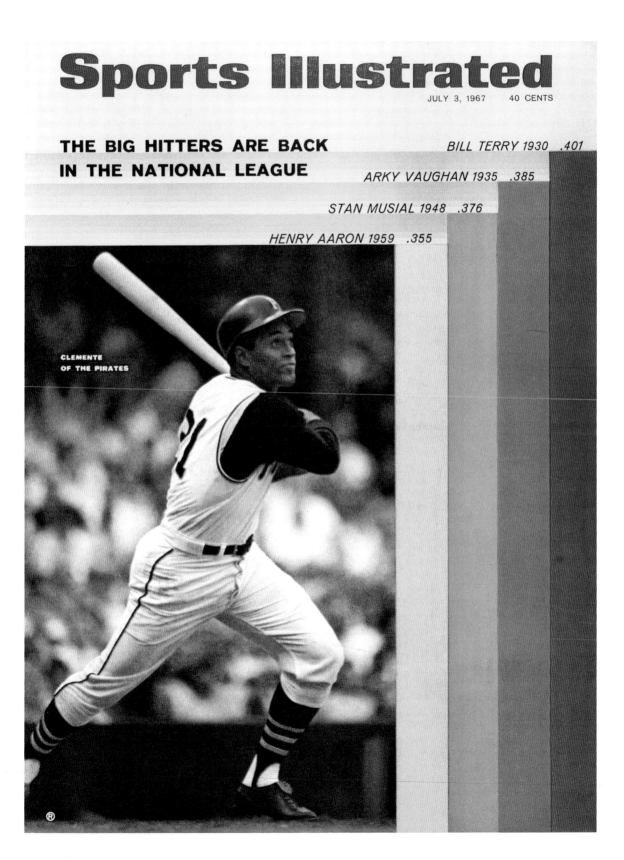

CLEMENTE
OF THE PIRATES

®

THE **3,000**TH HIT

Roberto Clemente talks with reporters after his historic game. Three months later he would die in a tragic plane crash on the way to deliver supplies to earthquake victims in Nicaragua.

PITTSBURGH, PENNSYLVANIA
1972

Later, in the victorious clubhouse, Clemente began his comments to a national television audience by thanking his family back in his native Puerto Rico in Spanish.

"It made a point of not only is this guy a great player," says baseball historian Bruce Markusen, "but he's very proud of where he hails from. That was an extremely important series not just for Clemente, but for Latin players in general."

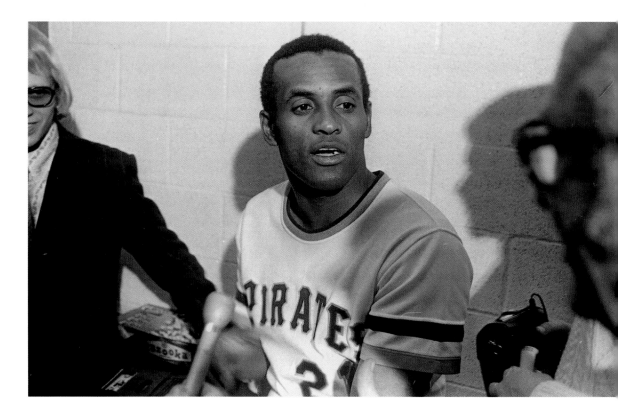

As the 1972 season began, Clemente needed 118 hits to reach 3,000 for his career and ensure his induction into the National Baseball Hall of Fame in Cooperstown. In the team's final home game, Clemente was one hit away when he doubled into the left-center gap. After he reached second base, Clemente doffed his helmet to acknowledge the standing ovation by the hometown crowd. Clemente never got a chance at another World Series ring after the Pirates lost in the National League Championship

Series to the Cincinnati Reds. That ball club—nicknamed the "Big Red Machine"—included Tony Perez from Cuba, Cesar Geronimo from the Dominican Republic and Dave Concepcion from Venezuela.

With the season over, Clemente went home to Puerto Rico. When an earthquake ravaged Nicaragua, he commissioned a plane and loaded it with food and supplies to bring to the survivors.

"Any time you have the opportunity to accomplish something for somebody who comes behind you and you don't do it," Clemente once said, "you are wasting your time on this Earth."

The plane took off on New Year's Eve 1972 and crashed into the ocean. Clemente's body was never found.

AN ICON REMEMBERED
Roberto Clemente entered
the Hall of Fame posthumously
in 1973.

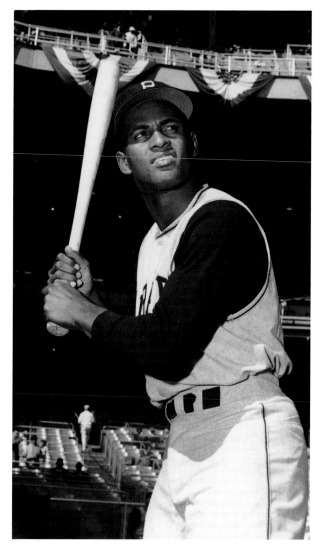

"This was a man who looked at the television pictures coming back from the moon and saw the world," longtime sports columnist Jimmy Cannon wrote in the *New York Post.* "Clemente thought of all the people who came together to put that guy there. He conceived of them as a brotherhood."

Carlos Delgado, who grew up in Aguadilla, Puerto Rico, says that Clemente "died the year I was born. My winter team—Santurce—is the same team he played for. He's something anybody from this island will never forget."

Jorge Posada also was too young to ever see the great Clemente play in person. But Posada's father was a baseball scout and often showed old footage of the Pirates' superstar in action to his son. "Everyone where I come from knows his story," Posada says, "the way he could play."

With Cuba off-limits to major league scouts and Puerto Rico too small for the

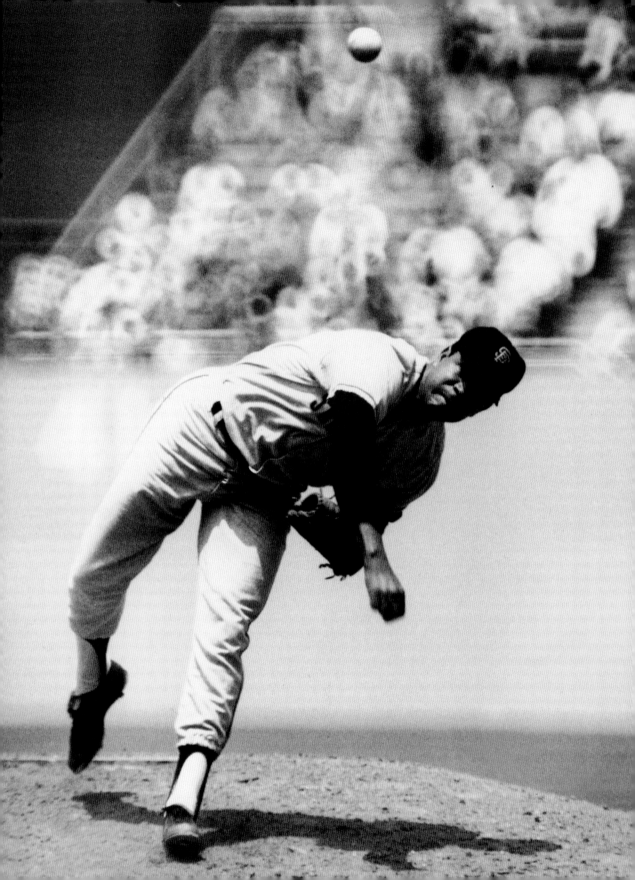

increasing demand for top players, professional teams turned their attention to the Dominican Republic. The Alou brothers (Felipe, Matty and Jesus) had already come from there as well as Hall of Fame pitcher Juan Marichal.

"They opened the door for us," Pedro Martinez says in the film *Republic of Baseball: The Dominican Giants of the American Game.*

Rob Ruck, the author of *The Tropic of Baseball: Baseball in the Dominican Republic,* says many fans forget that before Pedro, Manny Ramirez, David "Big Papi" Ortiz and Albert Pujols, there was the first group of ballplayers from the Dominican Republic. "I don't think we can really imagine what they were up against," Ruck adds. "That's why somebody like Felipe Alou, to me, is as important as Clemente. If Felipe and his brothers did not succeed, who knows if the next wave of players has that same chance to play in the majors? Who knows if the Dominican Republic becomes the baseball power that it is now."

One of the most spectacular pitching debuts in the majors belongs to Marichal, the first Dominican to be selected to the Hall of Fame in Cooperstown. He initially took the mound for the San Francisco Giants in a night game, July 19, 1960. Incredibly, he took a no-hitter into the eighth inning when his pitching coach recommended he throw a breaking ball instead of the fastball to Philadelphia Phillies pinch-hitter Clay Dalrymple. A bit fearful of going against his coach, especially in his first big league game, Marichal did as he was told. Dalrymple promptly laced the breaking ball into the outfield for a single. Good-bye no-hitter.

Cepeda calls Marichal "the best right-handed pitcher I've ever seen."

Cepeda, Marichal, Clemente and the Alous. These players soon gained a following within the U.S. Latino community. Although Omar Minaya was born in the Dominican Republic, his family moved to Queens, New York, when he was eight years old. Earlier on, Minaya felt homesick and disoriented in his new country. But in the summers, he would go to Shea Stadium, sit in the upper deck because his family couldn't afford the box seats, and watch the stars from the Dominican Republic and elsewhere in the Caribbean.

"I was a National League fan because that's the league in which the best Latins played in the 1960s and 1970s," Minaya says. "I'd see them out there on the field, making great plays, and my self-confidence got better,

Opposite:

"THE DOMINICAN DANDY"
San Francisco Giants pitcher Juan Marichal hid his choice of pitch with theatrical windups and high leg kicks. He entered the Hall of Fame in 1983.
LOS ANGELES, CALIFORNIA
Date Unknown

Following Pages:

FROM BLEACHERS TO THE DUGOUT
John Schuerholz, general manager, and Frank Wren, assistant general manager, of the Atlanta Braves chat with Omar Minaya, general manager of the New York Mets *(right)*, before a spring training game against the New York Mets at Tradition Stadium.
PORT ST. LUCIE, FLORIDA
2005

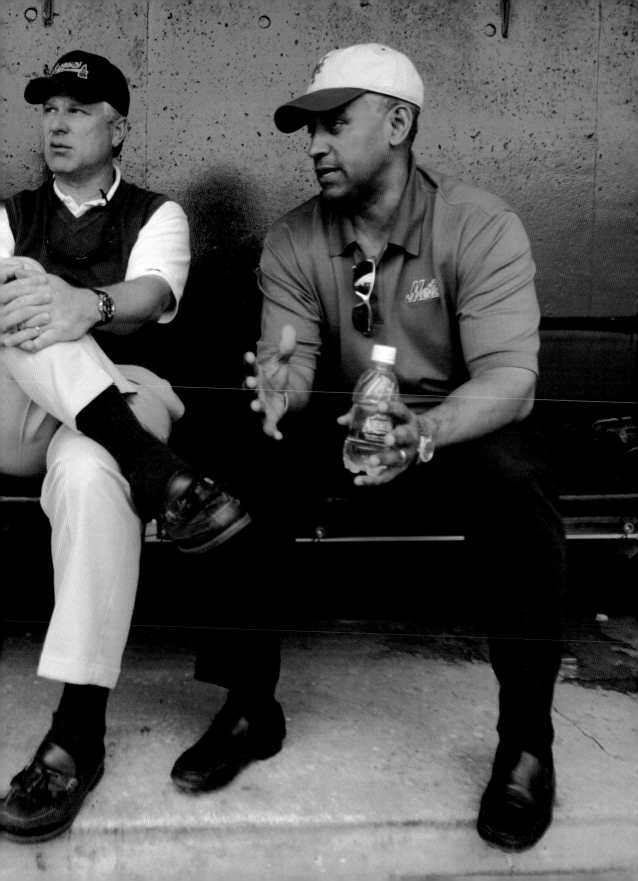

PANAMANIAN STAR

A hitting machine, Rod Carew played for the Minnesota Twins and the California Angels. In 1977, he flirted with hitting .400. Fourteen years later, he entered the Hall of Fame.

ANAHEIM, CALIFORNIA
CIRCA 1979-1985

too. I felt I could make it." After a short-lived, minor league career with the Athletics and Mariners, Minaya worked his way through the ranks to become the first Latino general manager at the major league level.

By then it was not just Latinos who took notice how the game was changing, either. "Babe Ruth, everybody knows who he is," says New York Yankees manager Joe Torre. "The next big move was Jackie Robinson. Then the Latin player took the game to another level."

One town alone in the Dominican Republic—San Pedro de Macoris—eventually sent a number of stars to the major leagues, including Tony Fernandez, George Bell, Pedro Guerrero and Sammy Sosa. "Dreaming of playing in the major leagues is as Dominican as sugarcane or merengue," historian Milton Jamail writes in *Baseball as America*. "The intense drive to excel in baseball is derived from the love of a game that permits young men to dream of escaping poverty. This route to a better life doesn't exist in Haiti, the country that shares the island of Hispaniola with the Dominican Republic."

Yet as baseball moved into the modern era, the hunt for talent became so intense even countries that had once been dismissed by big-league scouts proved capable of producing a superstar or two. Rod Carew, for example, was born in Panama and his family moved to New York City when he was 15. The game kept a young Carew out of trouble and soon he gained a reputation as an impressive line drive hitter. He signed with the Minnesota Twins and improved his defense under the tutelage of manager Billy Martin.

In 1977, Carew made a run at one of the most hallowed standards in baseball. Nobody in the game had hit better than .400 in a season since 1941, when Ted Williams posted a .406 average. Ironically, Williams had more than a passing influence on the Latino emergence. His mother, May Venzor, was Mexican-American and Williams made a point of encouraging Orestes "Minnie" Miñoso after he broke into the major leagues. Carew finished the 1977 season with a .388 average—eight hits shy of the

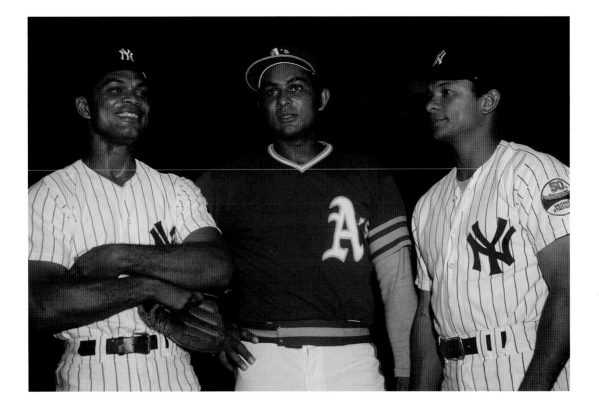

.400 plateau. Still, Carew's average was 50 points higher than the next-best batting average in the majors that season, the largest margin in baseball history.

Novelist F. Scott Fitzgerald was not much of a baseball fan. To him, the national pastime was "a game played by idiots for morons." In addition, Fitzgerald did not believe in second acts or eleventh-hour chances at lasting redemption. Perhaps that's why he looked down his nose at

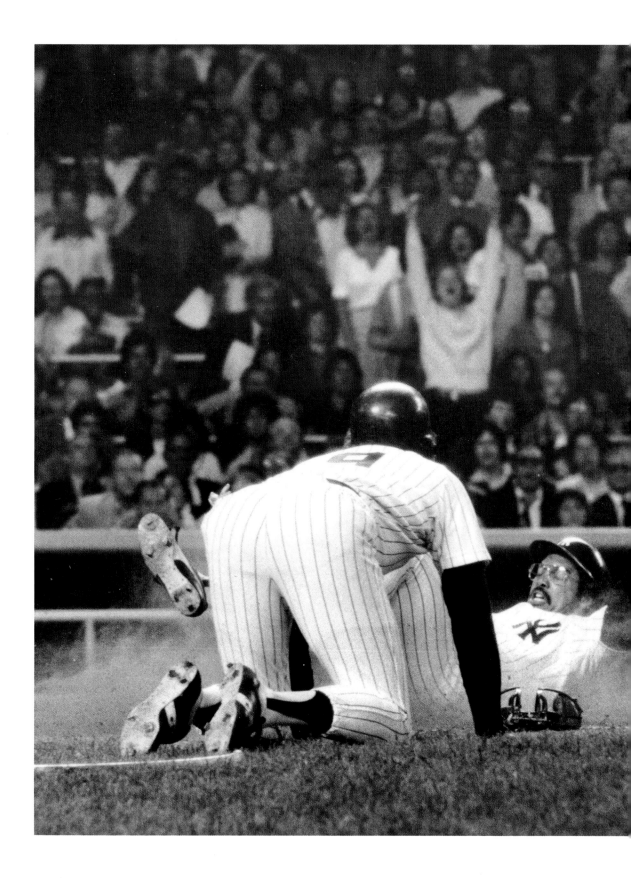

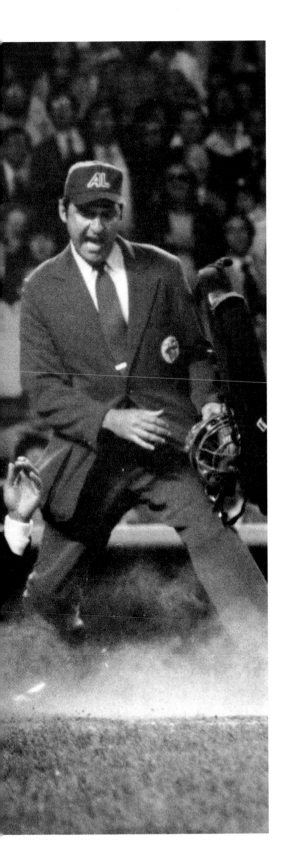

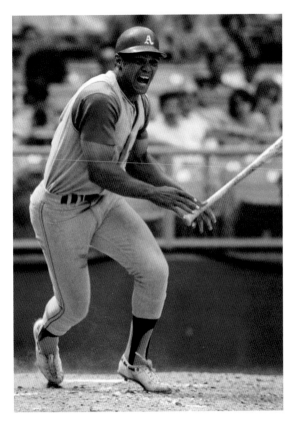

Opposite:

BRIGHT LIGHTS, BIG TALENT

He's out at the plate this time but Reggie Jackson's three home runs during Game 6 of the 1977 World Series remains the prime-time standard.

SEATTLE, WASHINGTON
1978

Above:

"MR. OCTOBER"

During 21 years at bat, Reggie Jackson earned a reputation for hitting the ball when it counted the most.

OAKLAND, CALIFORNIA
1969

baseball because the game is riddled with such moments.

A decade after the San Francisco Giants unraveled amid much acrimony and English-only edicts, the Oakland Athletics rose to prominence. In a story twist that often only baseball can provide, their march to the World Series offered a second chance to Alvin Dark.

The Oakland Athletics won three consecutive world championships in the mid-1970s and were as flamboyant as they come. Several of their stars— Rollie Fingers and Joe Rudi—were known for their Snidely Whiplash mustaches, white cleats or self-aggrandizing swagger. The club's cantankerous owner, Charlie Finley, wasn't above demoting anybody in his organization at any time.

At the plate, the Athletics were led by Reggie Jackson, who described himself as "a black kid with Spanish, Indian and Irish blood." That hodgepodge of genealogy didn't matter to Latino kids watching from afar. Andres Galarraga who grew up in shortstop-rich Venezuela began to idolize Jackson, especially after the slugger hit three home runs in a single World Series game.

"I thought of him as one of us," Galarraga says. "He and Roberto Clemente were the ones I paid attention to as a boy. I loved how they'd thump the ball, how far they could hit it. I knew I was never going to be a shortstop. Not the way I'm built. Guys who could hit. That's what I wanted to be." Galarraga went on to play 19 years in the majors and was a 5-time All-Star.

Still, regardless of how far somebody can hit the ball, the best player on most baseball teams is the shortstop, and the championship Oakland Athletics had one of the best in Bert Campaneris. Born in Cuba, he was the cousin of Jose Cardenal. In 1965, when the Athletics were located in Kansas City, Campaneris became the first player to play every position in a major league game. In essence, he did what Martin Dihigo never got the chance to do.

During the championship run, Campaneris paced the Athletics in hits and steals. He was the one who came around the bases when sluggers like Jackson, Rudi and Gene Tenace connected. After Oakland won the 1974 World Series, Dark—who had been criticized for his inability to communicate with Latino players while he managed the Giants—couldn't say

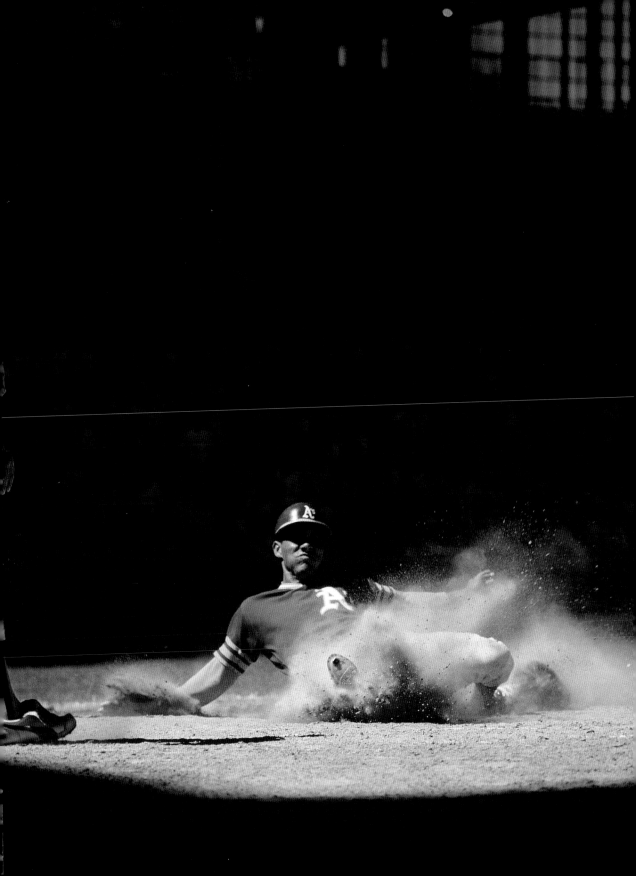

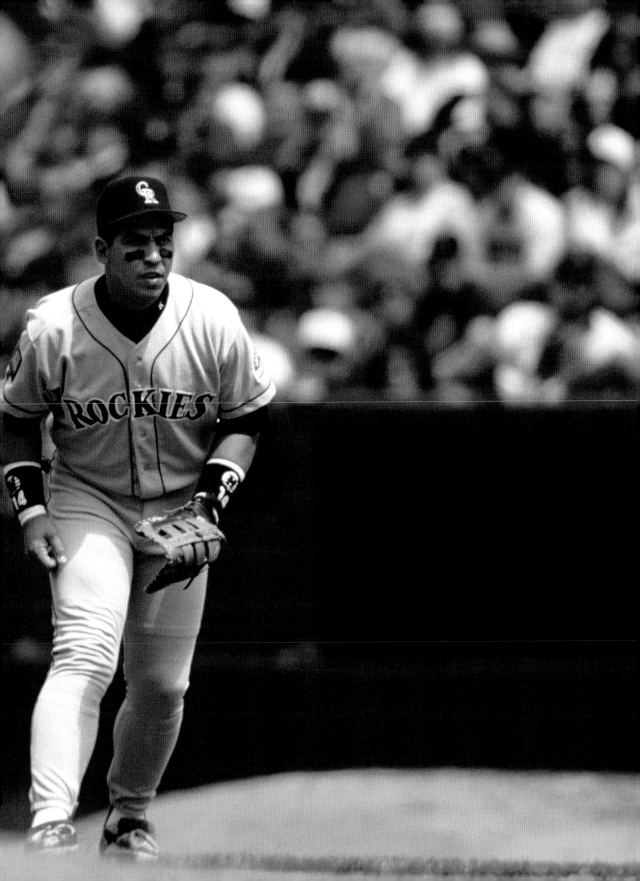

enough good things about Campaneris. Dark called him "the best offensive shortstop since Pee Wee Reese." One wonders how far such praise would have gone a decade earlier in San Francisco with Orlando Cepeda and the Alou brothers.

If Juan Marichal had one of the best inaugural games in baseball, Dennis Martinez had perhaps the best closing act for a Latino pitcher. The Nicaraguan broke in with Baltimore in 1976 and soon impressed Orioles manager Earl Weaver with his repertoire of pitches. But off the field, Martinez battled alcoholism and was eventually sent packing to Montreal.

In 1991, he led the National League with a 2.39 ERA for a last-place team. More important, on July 28, Martinez became the first Latino and only the thirteenth hurler in major league history to pitch a perfect game. He did so on the road, against the Dodgers, and became the first pitcher to throw a perfect game at Dodger Stadium since Sandy Koufax in 1965. Martinez finished his major league career with 245 victories, two more than Marichal.

As the game grew to its present form, with more than one-quarter of the players foreign-born, such countries as Nicaragua and Panama became known for producing an occasional superstar, like a Martinez or a Carew. Other countries, like Venezuela and the Dominican Republic, became famous for churning out quality players. As of September 24, 2007, 457 from the Dominican Republic have reached the major leagues since 1901, many arriving since the early 1960s, according to *The New York Times*.

Meanwhile, Mexico fell somewhere in between those two classifications. Even though it produced a batting champion in Bobby Avila and an All-Star relief pitcher in Aurelio Lopez, the country was more famous at one point for its rival professional league than any particular player. During the 1940s, Mexican millionaire Jorge Pasquel lured such stars as Satchel Paige, Danny Gardella and Josh Gibson south of the border with big contracts. Determined to put Mexico on the baseball map, Pasquel then began to entice prominent major leaguers to consider playing in Mexico. After Rogers Hornsby arrived to manage, Pasquel considered making a run at signing Joe DiMaggio, Stan Musial and Ted Williams. That's when Major League Baseball commissioner Happy Chandler stepped in. He declared the Mexican League an "outlaw" operation and players signing there could face

FERNANDOMANIA

Looking to the heavens, left-hander Fernando Valenzuela has one of the most impressive rookie seasons in baseball history.

1982

a lifetime ban against playing in the majors. Except for Avila winning the batting championship with Cleveland in 1954, Mexico was considered a baseball backwater until 1981.

That's when Los Angeles Dodgers manager Tommy Lasorda took a chance on a 20-year-old Mexican named Fernando Valenzuela. Valenzuela was named to start on Opening Day mainly because the rest of Lasorda's pitching staff was hobbled by injuries. Valenzuela won that first game, a 2-0 shutout. He followed that with another complete-game victory on the road. By early May, Valenzuela was 7-0 and had given up only two runs. His five shutouts in seven games was the biggest story in sports and a growing legion of fans nationwide followed his every move. Fernandomania was born.

Years later, teammates would compare the adulation and crowds with what the Beatles had encountered during the 1960s. The Dodgers began taking turns driving him to the ballpark, helping him sort through his mail, even cooking meals for him. For the games Valenzuela started, an additional 9,000 fans filed through the turnstiles at ballparks across the National League. "He was 17, but he pitched like he was 35," says Dodgers scout Mike Brito about Valenzuela's performance in 1978. "He was one of those guys that come along once every 50 years."

Mike Scioscia was often the catcher when Valenzuela pitched. Scioscia began to learn more Spanish so they could communicate better—a skill that served him well years later as a big league manager. "What made Fernando unique was how he handled himself in that situation," Scioscia says. "He knew that his passion was to pitch, to play baseball and that's where his focus was. He would mess around a little bit and have a lot of fun, but he knew what he wanted to accomplish and what he had to do."

Below:

"EL TIANTE"

Cuban President Fidel Castro
let baseball legend Luis Tiant Sr.
(middle) visit his son, Red Sox
pitcher Luis Tiant Jr. *(left)*, whom
he had not seen in 14 years. Tiant
Sr. threw the first ball of the game.

BOSTON, MASSACHUSETTS ,**1975**

Miñoso, Cepeda, Carew—each of them had thrilled a particular community or fans of a specific team. But what made Valenzuela's rise so stunning was that the nation, for an entire season, became enthralled with a ballplayer who hailed from outside our borders. "It was the year of Fernando," legendary Dodgers announcer Vin Scully says.

At the end of the 1981 season, Valenzuela had eight shutouts and became the first rookie to win the Cy Young Award. His ascension would

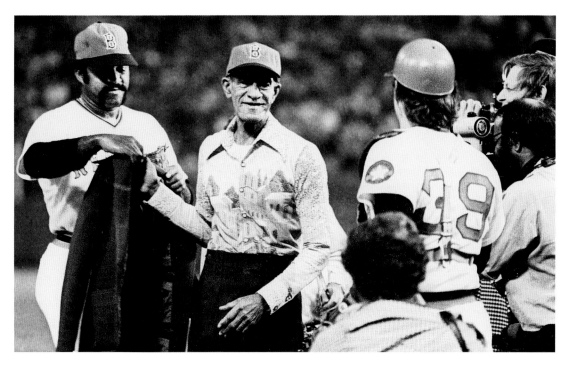

Below:

"EL TIANTE"

Cuban President Fidel Castro
let baseball legend Luis Tiant Sr.
(middle) visit his son, Red Sox
pitcher Luis Tiant Jr. *(left)*, whom
he had not seen in 14 years. Tiant
Sr. threw the first ball of the game.

BOSTON, MASSACHUSETTS ,**1975**

Opposite:

"EL PRESIDENTE"

Montreal Expos pitcher Dennis
Martinez celebrates with his
teammates after the game
against the Los Angeles Dodgers
when Martinez pitched a perfect
game 2-0.

LOS ANGELES, CALIFORNIA
1991

also have a profound impact upon the next wave of Latino ballplayers. Nomar Garciaparra grew up as a first generation Mexican-American in southern California. He was a Dodgers fan and as a youngster followed Valenzuela's every start.

"Fernando was such a big deal to anybody of Mexican descent, and that included such a huge part of Southern California. It included my family," Garciaparra says. "They were all directly from there. So they were all for Fernando."

So was much of the rest of the country.

THE PASSION OF CARACAS

Milton Jamail
author of *Venezuelan Bust,
Baseball Boom: Andres Reiner
and Scouting on the New
Frontier of Baseball* and *Full
Count: Inside Cuban Baseball*

It was during a game in November 2000 that I first discovered the passion for baseball that simmered inside the citizens of Caracas. I was sitting in the Estadio Universitario with more than 20,000 fans, many of whom had brought banners, chants, whistles and air horns, ready to participate in the most Venezuelan experience of all in baseball—the Caracas-Magallenes match. Salsa music and a recording of a roaring lion punctuated the constant clamor of the loudspeakers. The atmosphere was part World Cup soccer, part seventh game of the World Series, yet it was a semi-regular event. It's no wonder that the publication *Baseball America* lists the game as one of the must-see attractions in baseball.

Some of the Latino players who had returned from America during the winter season played that night. As Bobby Abreu of the Philadelphia Phillies and Melvin Mora of the Baltimore Orioles walked onto the field—Abreu wearing the white-and-blue-pinstripe jersey of Caracas and Mora wearing the visiting gray of Magallanes—the crowd roared its approval. Each time either man came up to bat, the crowd grew even louder.

The fans seemed evenly divided between both teams. They wore game jerseys or team caps, opponents sitting next to unified sections and sometimes interspersed, a kaleidoscope of rivals and compatriots blanketed every square inch of the stadium. When Mora hit a ball that looked like it could sail out for a home run, the Magallanes fans cheered as the ball sailed toward the fence. But when a Caracas right fielder made the catch at the warning track, an ear-piercing roar of delight emanated for the Caracas fans.

Often the pretense of the healthy rivalry sometimes disappeared when the game ended. Phil Regan, a baseball manager in the winter ball league, swears that some people bring two caps, one for each team, to the stadium every time. This way they can leave with the winning cap rather than a losing one.

"The love of baseball becomes even greater with the increasing number of players getting to the big leagues," says Giner Garcia, executive director of Venezuela's Hall of Fame. The rapid increase in the number of local players reaching the major leagues is astounding: almost three-fourths of the 214 Venezuelans in 2007 who have played in the major leagues in America made their debut after 1990. A downturn in the local economy may have been a factor in influencing young boys trying to make a better life.

For major leaguer Morgan Ensberg, who played for the Caracas team in 2000, the rivalry remains "the most incredible baseball game I have ever seen. The atmosphere is very similar to the final game of the College World Series. In fact, it's just like the last out of the College World Series, but it goes on for the entire game."

ROOTS RUN DEEP

In the town where President Hugo Chavez grew up, kids play a pickup game of baseball with whatever equipment they have.

SABANETA, BARINAS, VENEZUELA
2007

For the Venezuelan players, the game has also become a lesson in dealing with pressure, of playing before large crowds in clutch situations. Mora once told me that at the end of 1999 season Bobby Valentine, then manager of the New York Mets, wondered how Mora would do in the heat of a pennant race. So Valentine asked his veteran second baseman, Venezuelan Edgardo Alfonso, about the rookie.

"If he can play in a Caracas-Magallanes game," Alfonso replied, "he can play anywhere."

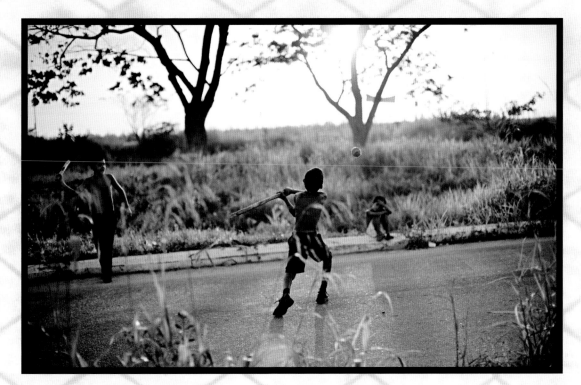

Abreu took the 2005–2006 winter season off, but when he entered the stands of the Estadio Universitario during a Caracas-Magallanes play-off game dressed in blue jeans and sports coat, several thousand fans still rose to applaud him. When Abreu walked onto the field between innings, he was greeted with another thunderous ovation. He stopped near home plate, waved at the fans with his left hand and placed his right hand over his heart in recognition of their support and admiration. Throughout Venezuela there were boys watching and dreaming that they would be the next Bobby Abreu.

THE NEW FRONTIER:

As the 2007 season began, no sport in America had a more international workforce than Major League Baseball. Not only were the players beloved where they grew up, but they were often cheered as native sons in the United States because of the talent and passion they brought to the national pastime. Many of baseball's top superstars—Alex Rodriguez, Vladimir Guerrero and Albert Pujols—seemingly belonged to several countries at once as their exploits extended far beyond boundaries and borders, old allegiances and rooting interests.

The Dominican Republic and Venezuela ranked first and second as the top exporters of baseball talent. After the Alou brothers debuted in the 1950s, the number of Dominican-born players in the major leagues rose to roughly six percent into the 1980s. But with the academy system taking hold, that percentage has more than doubled in the last 15 years, according to *The New York Times.* In addition, the percentage of Venezuelan ballplayers has nearly tripled since the days of Luis Aparicio and Davey Concepcion.

When baseball coach Junior Noboa now gazes upon the 50 or more prospects that practice daily at his academy outside of Santo Domingo in the Dominican Republic, he has an eye out for the handful who could make the passage north. A top prospect must be able to do more than hit a curveball or paint the outside corner. He has to show that he has the intangibles to succeed in a new land, a new culture. That's the first roll of the dice in this age of globalization in sports.

"I need to find players with the right mental makeup," says Noboa, who played in the major leagues for eight seasons. "They can't just be good players. They have to be ready to make the leap. To go from this world and catch on in another world that's totally different on so many levels."

By the 1990s, nearly every major league organization—as well as professional teams from Japan—had a baseball academy in the Dominican Republic. If anybody wants to see the future of sport in the era of globalization, they need only look inside such encampments. Despite decades of frustration and failure, the longtime national pastime learned that an effective policy for immigrant labor not only made business sense, it was good citizenship. While debate rages in other arenas about immigration reform, Major League Baseball (MLB) has managed to procure its own type of a guest-worker program.

Preceding Pages:

SUCCESS AT A YOUNG AGE

Miguel Cabrera (center) of Venezuela is the third-youngest player to reach 500 career runs batted in. Mel Ott and Ted Williams accompany him.

KISSIMMEE, FLORIDA

2006

Opposite:

FIRST STEPS

In a graffiti-filled dugout, sitting on a cooler surrounded by discarded paper cups, this young Dominican prospect for the San Diego Padres seems to drift away in his thoughts during a baseball game.

SANTO DOMINGO,
DOMINICAN REPUBLIC

1993

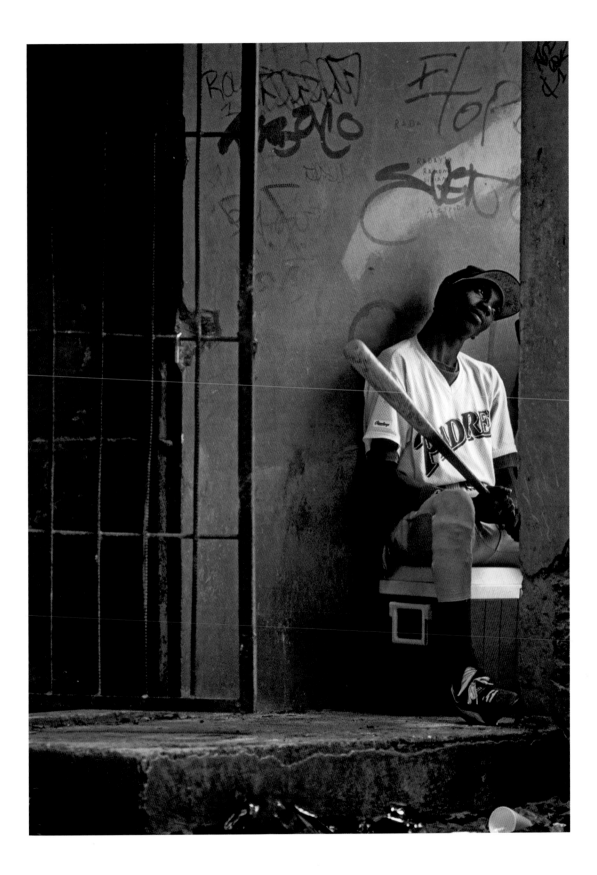

RECRUITING IN THE D.R.

Young recruits have to earn
their baseball jerseys at the
baseball academies that have
sprung up in the Caribbean.

SANTO DOMINGO,
DOMINICAN REPUBLIC
1996

This approach has allowed the sport to foster young stars and a new fan base. "Without the influx of Latin players, we certainly wouldn't have thirty major-league teams," Chicago White Sox executive Roland Hemond tells The *Kansas City Star*. "So they've been a great boon for our game, its growth in franchises, as well as in quality of play."

On the emerald fields outside of Santo Domingo, the academy's pecking order is as finely delineated as rank at an army base. Those out of uniform, wearing T-shirts or a jersey from home, are there for probably a

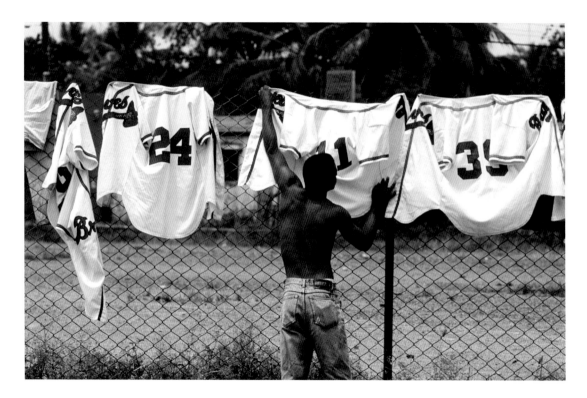

day or so. If they gain the attention of Noboa or one of his coaches they will be given a 30-day tryout and a purple jersey. If they continue to excel, they will be assigned a black-mesh jersey.

"This is the base of today's baseball pyramid," says consultant Milton Jamail.

Noboa has estimated that of the 50 players he was training that day, less than six would travel north to begin competing in the minor leagues.

Of course, fewer still would someday reach the major leagues.

Pressure to be awarded a visa to the U.S. by Noboa or any other academy director dramatically raises the stakes and can lead to poor decisions by the players. Approximately one-half of the players caught taking steroids since testing began in 2004 have been from Latin American countries. "They come from such poorer countries," major league catcher Javy Lopez, who is from Puerto Rico, told *Newsweek* magazine in 2006, "and part of it has to do with that sense of desperation to make it in the big leagues and become a superstar."

Unsigned players from the U.S., Canada and Puerto Rico are subject to Major League Baseball's annual amateur draft. According to Arturo J. Marcanco Guevara and David P. Fidler, authors of *Stealing Lives: The Globalization of Baseball* and the *Tragic Story of Alexis Quiroz,* the draft made the process "formal and transparent, so vulnerable teenagers did not have to deal with smooth-talking major-league scouts." Other countries, such as Mexico, Japan and Korea, have national federations that regularly negotiate with MLB teams before their players can enter the major leagues. The rest of the world, which includes Venezuela and the Dominican Republic, have been compared to the chaotic nature of settling the early American Wild West.

THE CALL OF AMERICA
Rey Ordoñez, a shortstop for the Chicago Cubs at the end of his career, defected from Cuba in 1993. He earned three Gold Glove Awards while playing for the New York Mets.
CHICAGO, ILLINOIS
2004

For instance, prospects in Latino countries are at first represented by *buscones,* or local scouts, when they start. *Buscones* are not licensed or governed and they routinely take 25 percent of the first contract and the signing bonus. Some of the *buscones* have been less than helpful. Alfonso

Soriano's first professional contract, for example, linked him with a Japanese team for his entire playing career. He had to officially retire to escape that pact and eventually reach the U.S. major leagues.

What was once simply a game that united communities in Venezuela or the Dominican Republic has become an industry, says sports anthropologist Alan M. Klein. In 2004, nearly 1,400 Dominicans were in the U.S. minor leagues and thousands more were back on the island trying to be signed. If one or two prospects pan out a year, the entire process pays for itself. Those in baseball justify this "boatload mentality" because they're giving kids who would otherwise live the rest of their lives in poverty a chance.

Yet, as historian Roberto Gonzalez Echevarria points out, there's plenty of room for unfairness or abuse, especially when Latino prospects are often perceived as "cheap and, ultimately, disposable talent." In 1985, the Texas Rangers signed Sammy Sosa, who would go on to hit more than 600 home runs in the majors, to a $3,500 contract. In comparison, many U.S. players routinely receive larger contracts and often a signing bonus.

Whether Venezuela will surpass the Dominican Republic in terms of number of ballplayers reaching the majors may have as much to do with politics as player development. Some big-league teams aren't anxious to conduct business with a nation whose leader is Hugo Chavez. Old-timers see him as the second coming of Fidel Castro, and that perception was only reinforced when the socialist leaders participated in an exhibition baseball game between the two countries in 1999. In a contest that was televised in both countries, Chavez played all nine innings, starting on the mound and then moving to first base. Team Cuba won 5-4 and afterward Chavez said the game had deepened the friendship between the two countries. That's something MLB teams, which have been closed off from Cuban talent for nearly a generation, didn't want to hear.

Chavez aside, one of the most prominent players ever to come out of Venezuela is Omar Vizquel. After being a member of the Seattle Mariners, where he once saved a teammate's no-hitter by fielding the ball bare-handed and throwing on to first for the final out, Vizquel became an integral member of the Cleveland Indians American League pennant winners. In 2007, at the age of 40, he was still playing, as the

Opposite:
OMAR VIZQUEL
Nobody plays the shortstop position with more flair than Venezuelan Omar Vizquel. With nine consecutive Gold Glove Awards to his name, many such as Hall of Fame player Cal Ripken Jr. say he deserves to be inducted into the Hall of Fame one day.
CLEVELAND, OHIO
2000

Following Pages:
STRENGTH IN COMMUNITY
New York Yankees pitcher Mariano Rivera plays stickball with children in Panama, his home country, after his first season in American baseball.
PUERTO CAIMITO, PANAMA
1996

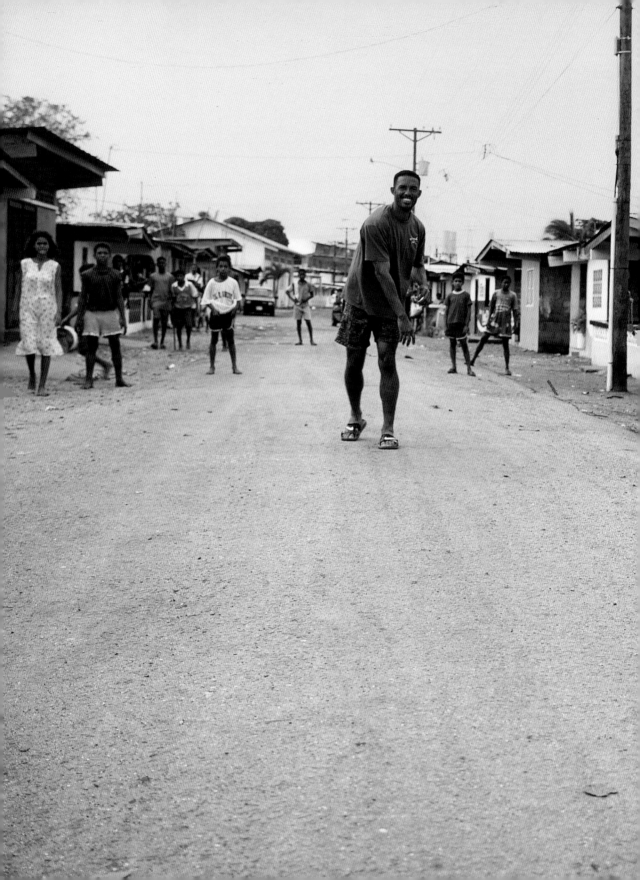

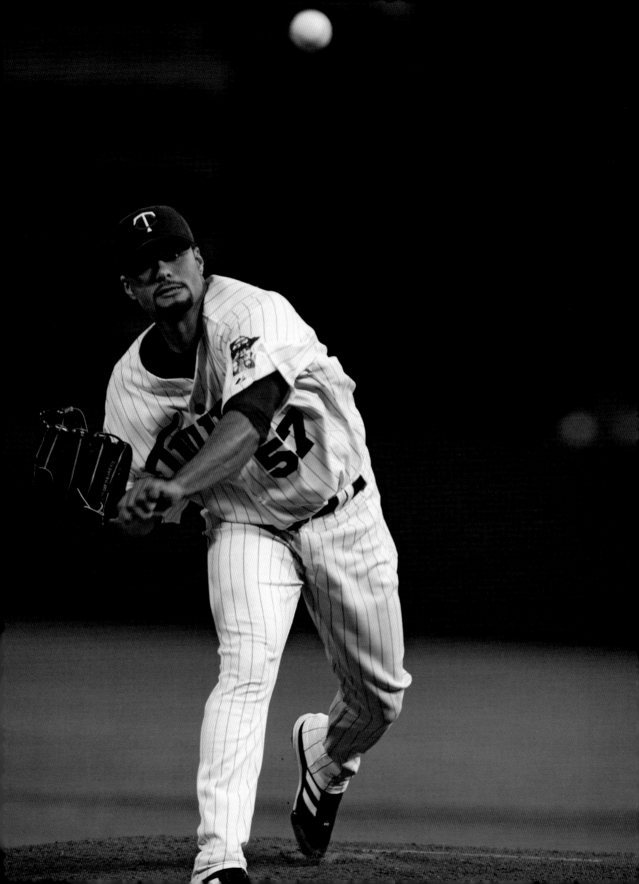

shortstop for the San Francisco Giants.

"It doesn't surprise me that he's playing at 40 years old because he takes care of himself," Cal Ripken Jr., a guy who knows a thing or two about durability, tells the *San Francisco Chronicle*. "In my opinion, he's one of the best shortstops in my era, so I would certainly consider him a Hall of Famer."

The past has always been in play for Vizquel. Since he was nine years old, the shortstop for the national youth team, Vizquel has worn number 13. He does so in honor of Dave Concepcion, a former baseball player from his native country. "He's the one I saw playing," Vizquel explains. "The one that I liked. The one I looked up to."

Of course, today Venezuela is much more than a shortstop pipeline. By 2007, Johan Santana had already won two Cy Young Awards, as the top pitcher in the American League, and seemed destined to win more. Miguel Cabrera of the Florida Marlins followed in Andres Galarraga's footsteps, proving that Latino players could certainly hit the ball hard.

Despite such long odds, the dream of baseball glows bright in these lands. Ask a prospect about those who preceded him and most will know the stories. How Soriano was so skinny and slow growing up that he was nicknamed "Mule." How Sammy Sosa was a shoeshine boy before he signed a big-league contract. How Vladimir Guerrero was only invited to the Los Angeles Dodgers academy because his older brother, Wilton, was turning heads there.

Vlad hung at the academy for several weeks before the Dodgers passed on him. Guerrero's swing was deemed too slow, too looping, to make it in the major leagues. A few days later, Guerrero caught a ride on

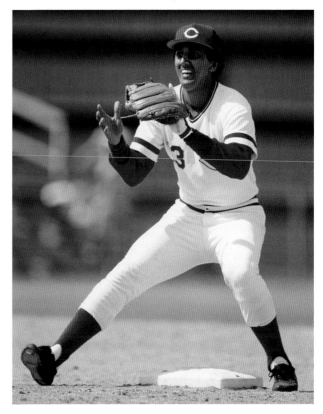

Opposite:

JOHAN SANTANA

A Venezuelan, Santana established himself as one of the top pitchers in the game. Here, he's pitching in the 2006 American League Championship Series against the Oakland Athletics.

MINNEAPOLIS, MINNESOTA

2006

Above:

DAVEY CONCEPCION

Overshadowed by teammates Johnny Bench and Joe Morgan, Venezuelan shortstop Davey Concepcion developed the one-hop throw to first base.

1982

Below:

"THE MULE"

Once considered to be too slow
to play in the major leagues,
Alfonso Soriano today reminds
many of a young Hank Aaron.

2001

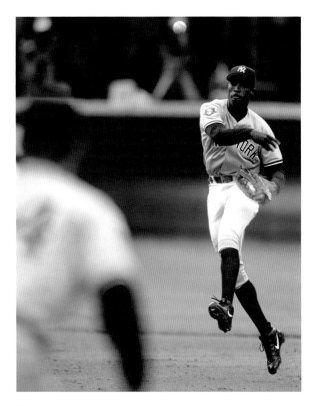

Opposite:

SAMMY SOSA

The home run race between
Sammy Sosa and Mark McGwire
during the summer of 1998 reju-
venated the game of baseball.

2001

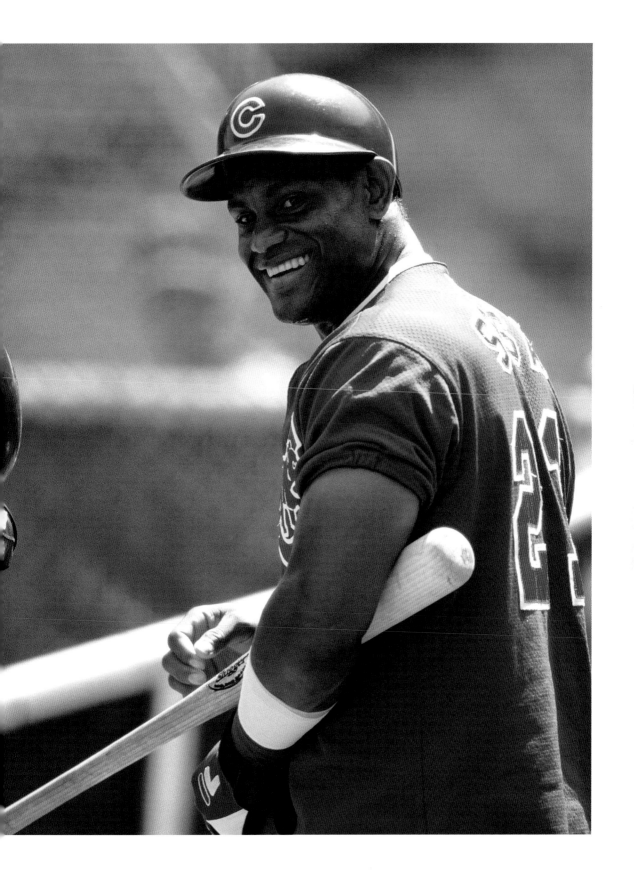

the back of a friend's motorcycle to a tryout held by the Montreal Expos. He pulled a muscle running to first base after his only at-bat. The Expos scout mentally flipped a coin and decided to offer Guerrero a contract. Three years later, Guerrero was in the major leagues.

"Baseball has attained such importance to players like me, those from the Dominican Republic, because it's the world," Guerrero says. "It's the world that you can reach, if you are fortunate and good and work hard.

It's where it all begins and ends."

It's also a world in which the stories sometimes begin to blend together and bleed across borders. Ask an American kid about Albert Pujols or Alex Rodriguez and they will probably claim them as their own—pure red, white and blue. After all, Pujols grew up in the United States and

Rodriguez was born in New York City. Unlike the first wave of Latino stars—Miñoso, Marichal and Alou—many of today's ballplayers have a foot planted in both their homeland and in America. The common experience that many of them share is that their paths to the majors were often determined by perseverance and sometimes good fortune.

Pujols's family migrated from the Dominican Republic to the United States when he was ten, settling in Independence, Missouri. Despite a stellar high school career, few teams were interested in signing Pujols. The St. Louis Cardinals drafted him in the thirteenth round of the 1999 draft and he reached the majors for good two years later, winning Rookie of the Year honors in the National League.

Today Pujols not only ranks as one of the best active players, but he's emulating many of the all-time greats. He's the first player since Ted Williams to begin his career with six consecutive 100 RBI seasons. In 2005, he was the league's Most Valuable Player and nearly led the Cardinals to the World Series with a dramatic home run with two outs in the ninth inning against the Houston Astros. For St. Louis fans, Pujols's blast ranks as one of the most memorable postseason home runs ever.

After the game, Pujols flew home on the team charter. At four a.m., according to the *St. Louis Post-Dispatch,* he opened the front door of his home to find his five-year-old son, A.J., waiting for him.

"I love you, Dad," the boy said. "Glad you're home."

Following Pages:
"MIGGI"
Miguel Tejada of the Oakland A's celebrates his game winning hit at the Network Associates Coliseum on August 3. The Oakland A's defeated the New York Yankees 2-1.
OAKLAND, CALIFORNIA
2003

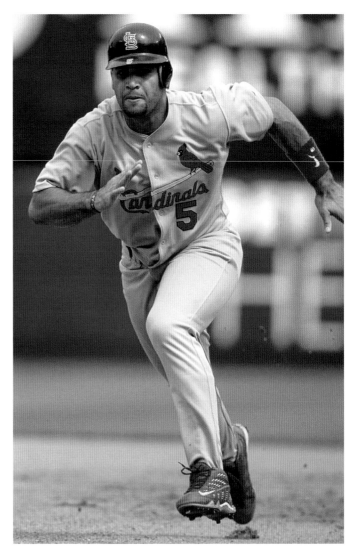

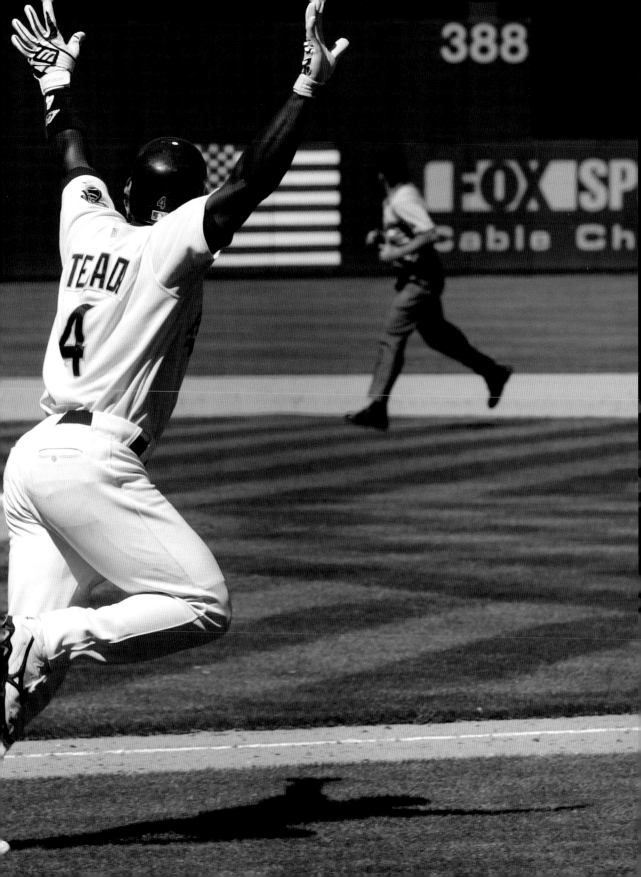

Below:

"A-ROD"

Alex Rodriguez pursues a pop fly. Among the highest-paid players in sport, he became one of the most consistent home run hitters in baseball history.

OAKLAND, CALIFORNIA

2002

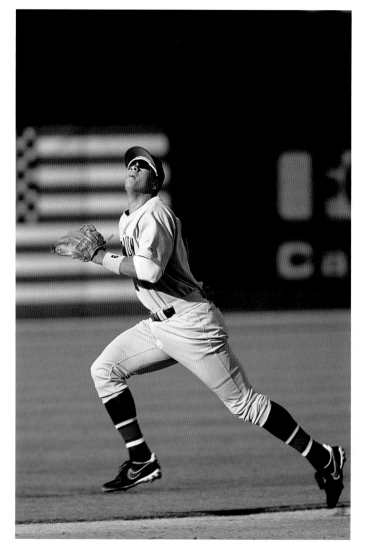

Then over his shoulder as he went upstairs to bed, A.J. said, "Nice home run."

In many ways, Alex Rodriguez's story parallels Pujols's. Born in New York City, A-Rod moved with his family when he was young back to the Dominican Republic. When the economy slowed on the island, the Rodriguez family moved again, this time to Miami. Looking for a way to fit in, young Alex often watched the local baseball team practice in the afternoon outside his elementary school.

One day the regular catcher didn't show up and the coach asked Rodriguez if he could play the position. Even though Rodriguez had never played catcher in his life, he told the coach he could. Soon afterward Rodriguez's father left to work in New York. He never returned to the family. The baseball team and its coach became a second family for Rodriguez.

"I love the game of baseball," says Rodriguez, who ranks among the highest-paid players in the game. "That's what a lot of people really don't understand about me. That's what keeps me going."

Sometimes being a citizen of the world can be complicated, though. Before the inaugural World Baseball Classic, Rodriguez was torn about which squad to play for—the United States or the Dominican Republic. He eventually decided to play for Team USA even though he had once said, "My roots are Dominican. That's where my parents were from."

More than a half-century ago, Jackie Robinson broke the color barrier in U.S. sports. While MLB didn't volunteer for the social role, it did show the rest of the country that black and white could get along on the same team. A similar evolution continues today between white and brown. Today more teams have bilingual coaches, trainers and front office personnel from rookie ball on up to the majors. The Cleveland Indians and the New York Mets not only teach the English language to their top prospects,

but they also send them to school in the Dominican Republic to earn their high school diplomas while they practice baseball.

By 2050, half the population in the U.S. will be non-Hispanic white, according to the U.S. Census projections; the other half will be people of color, with Latinos representing the largest group. "I was born a minority," says author Paul Cuadros, "but I will not die a minority. America is in the midst of fundamental population changes that will forever alter its

Above:

CAMARADERIE

Miguel Tejada is greeted by teammates Albert Pujols and David Ortiz at the World Baseball Classic game between Australia and the Dominican Republic. The D.R. won 6-4.

KISSIMMEE, FLORIDA

2006

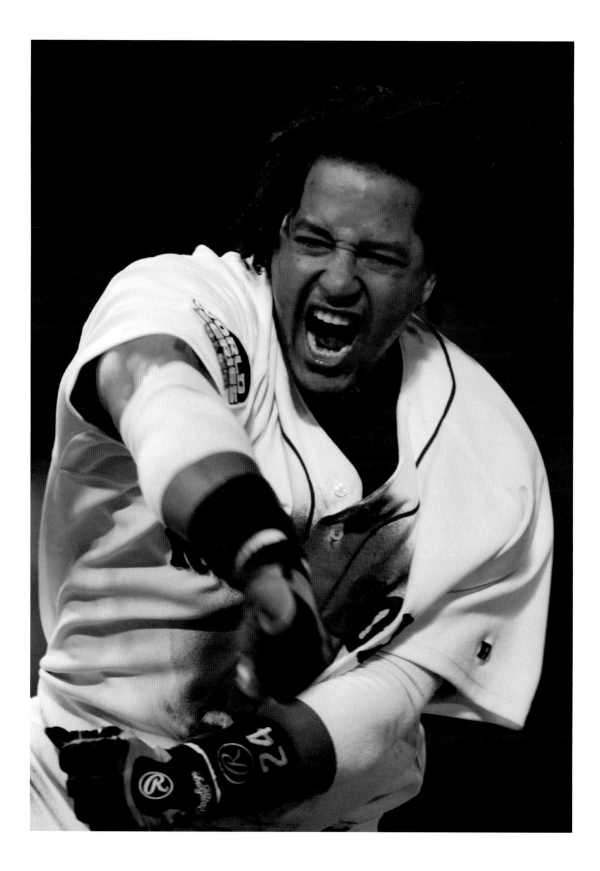

national character. In the next fifty years, there will be more people that will look like me, and the country's identity will be transformed."

The passion for the game exhibited by those from Venezuela, Cuba and the Dominican Republic has also helped rejuvenate a sport that had lost its way with the cancellation of the 1994 World Series. Too often players and managers fell in love with the three-run homer and predictable station-to-station baseball. Nostalgic for the old days when seemingly everybody took the extra base and the game was known for its hustle and zeal? That style of play can still be found in Latin America. The ones who have come so far from home may have given the sport a rare second chance, a final opportunity at redemption.

Baseball has begun to rediscover its past, its old swagger and style. In Southern California the Angels put pressure on the opposition by going from first base to third on almost any hit to the outfield. That's the way young prospects in their organization are taught. It's something manager Mike Scioscia, the guy who once caught the historic pitches thrown by Fernando Valenzuela, insists upon.

Other teams have found a new way of winning. The Boston Red Sox captured their first World Series in 86 years by bringing together a rambunctious cast of self-proclaimed "idiots." At the heart of their batting order were David "Big Papi" Ortiz and Manny Ramirez. In Detroit, an old-school manager named Jimmy Leyland and a Latino slugger who was supposed to be damaged goods, Magglio Ordonez, led the Tigers to the Fall Classic. New York Mets general manager Omar Minaya created a ballclub dubbed "Los Mets" because of its many Latino stars, including Carlos Delgado, Carlos Beltran and Jose Reyes, arguably the best new young player in the game.

In recent years, the All-Star Game has become a showcase for international talent. Venezuelan flags flew when Bobby Abreu won the home run hitting contest in 2005. Two years later, Vladimir Guerrero stepped up, eager to claim the crown. When he failed to homer on his initial swings,

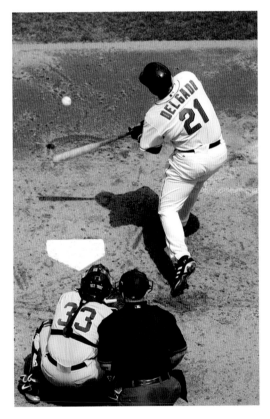

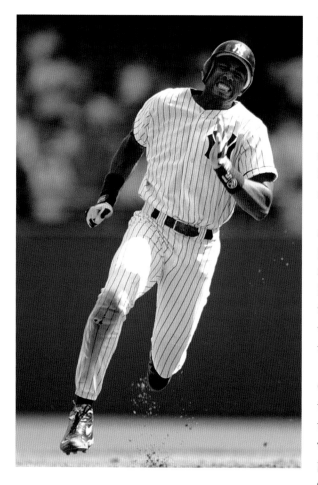

David Ortiz called for a halt in the proceedings. The Red Sox slugger and fellow Dominican lumbered to home plate and tossed away Guerrero's bat. Then he held out a large wooden case for Guerrero's inspection. From the case, Ortiz removed a new bat, kissed it and handed the new stick to Guerrero. It could have been a scene out of the film *The Natural*. Guerrero promptly hit five home runs out of his next nine swings and defeated Alex Rios in the finals.

The incident may have brought a chuckle to an American audience, but the story was already becoming fable—another tie that binds—throughout the Caribbean. The Home Run Derby may be all hype, but ballplayers concede that few things in the game are more difficult. That's why top stars often opt out. In batting practice, they usually work on hitting to all fields. Their efforts are shielded by a huge batting cage. But at the All-Star contest, the whole world is watching them swing for the fences.

So when Guerrero, one of the favorites, struggled in San Francisco, Ortiz and his compadres were there to break the tension. In the same city where Spanish had once been prohibited in the Giants' clubhouse, Ortiz's skit broke the ice. Fear of failure faded away and Guerrero, who often displays one of the biggest smiles in the game, laughed all the way to the title.

The next evening, before the All-Star Game itself, former baseball star Willie Mays—the "Say Hey Kid"—had the honor of throwing the ceremonial pitch. The legendary Giant walked through the gate into center field, his place for 22 years in the major leagues, to thunderous applause. He walked toward the infield down the aisle created by two lineups of All-Star players facing each other. Jose Reyes, the 24-year-old shortstop for the New York Mets and a native of the Dominican Republic, waited to catch the ball. Mays couldn't resist

waving him back a few steps as if to say he could throw it farther. The crowd roared.

After he uncorked a perfect pitch, Mays took time to sign the ball and hand it back to Reyes. "That's the most exciting thing to happen to me here," Reyes said, "to catch a ball from one of the greatest to ever play the game. I'll save that ball all my life. "

The torch had been passed. In a city where the rise of Latinos in base-

A STAR IS BORN
A young member of "Los Mets," Jose Reyes is already proving to be a player to be remembered.
SHEA STADIUM, NEW YORK
2006

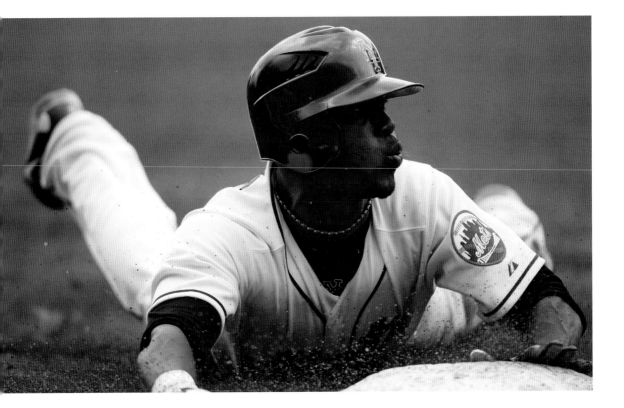

ball once caused such angst, everyone was smiling as Mays climbed into a 1958 pink Cadillac El Dorado to circle the field. Perhaps one day the 2007 season and the All-Star Game will be seen as the final link from the golden era of Mays and Miñoso, Aaron and Clemente, to modern times when baseball can extend far beyond borders and language, stereotype and prejudice.

"Past and present," Omar Minaya says. "That's one of the great things about baseball. You always have both."

Following pages:
SUNDAY AFTERNOONS
Young baseball players and a large local crowd get ready for the beginning of a game.
BANÍ, DOMINICAN REPUBLIC
1993

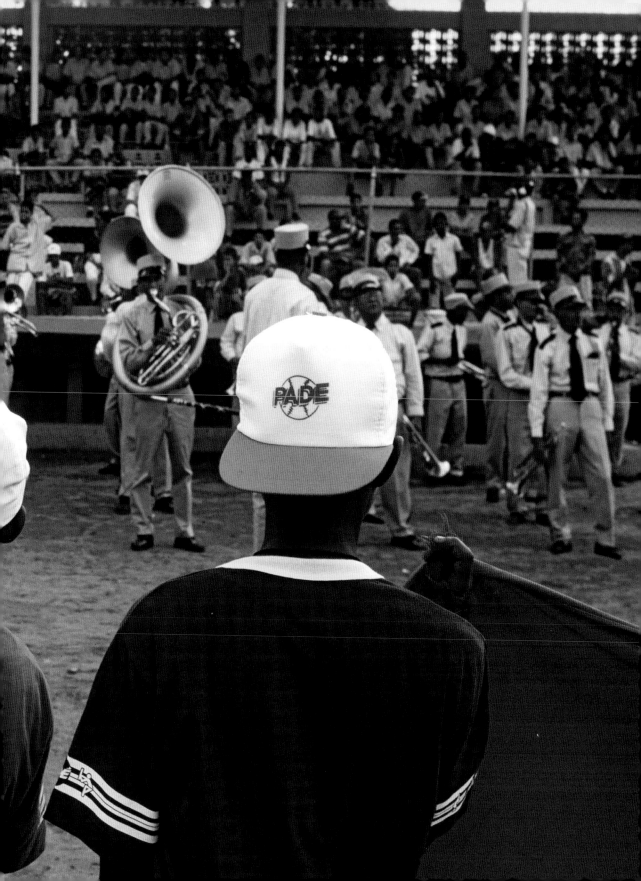

FAR FROM HOME

JOSÉ LUIS VILLEGAS

This is a story of passion for a game and for the American dream. It is an immigrant's story, the essence of which I saw written on a T-shirt worn by a prospect in the Dominican Republic. "Baseball is Life."

It is an ethic that drove the great, old Latino players of yore and it drives today's superstars and would-be superstars. It certainly drove Miguel Tejada, the star shortstop for the Baltimore Orioles. And it drove one of Tejada's best friends, Mario Encarnacion, a young man whose life exemplifies the profound motivations and dire consequences that some-times muddle the dreams of Latino baseball players.

In 1996, I met Tejada and Encarnacion in Baní, a coastal town in the Dominican Republic. They had grown up together playing baseball on dirt diamonds and they were budding prospects with the Oakland Athletics. Encarnacion was projected to be the star and he was given a signing bonus of $10,000 to prove it. They paid Tejada $2,000.

No one expected much from Tejada back then. He was 17 years old, loud and a bit wild. On my first trip to the island in 1993, I visited the Athletics training facility. Tejada, then a young recruit, jumped in front of my camera often. I shot a few frames just to make him go away. He want-ed attention.

But the camera doesn't lie and some of the images from Miguel's life are very poignant. He lived in a barrio adjacent to a landfill. The neigh-borhood was a maze of dirt streets and homes made of cinder blocks.

Humble people lived there and they allowed their children to run naked in the Caribbean heat. The images scrape the heart because they capture a young man on the razor's edge of his life.

When I look back on the first bus ride to the airport I shared with Tejada and Encarnacion, I can see the first glimmer of Tejada's future success. I can still hear the rumbling of the bus engine and the squeaking of the old seats as we bounced up and down on the dirt roads before the sun had risen. Encarnacion, Tejada and a handful of prospects were traveling to the United States for the first time to attend spring training camps. It was a quiet and tense time until Tejada started telling goofy jokes. Everyone started laughing and, for a fleeting moment, they were just kids.

Tejada made it into the major leagues just a year after that bus ride. By 1998 he was the starting shortstop for the Oakland Athletics. In 2002, he was the American League Most Valuable Player. And at the end of the 2003 season, he signed a six-year, $72 million contract with the Baltimore Orioles.

Encarnacion's story went the other way. He failed to live up to the promise envisioned by the scouts of the Oakland Athletics. He had brief stints in the major leagues with the Colorado Rockies and the Chicago Cubs but he never seemed to excel. He couldn't hit the curveball. Often injured, he didn't have Miguel's inner strength. Baseball can devour the weak. Even Michael Jordan, one of the most successful basketball players in history, was humbled by his failure to excel in the minor leagues.

In 2005, Encarnacion died in Taiwan where he was playing for the Mocoto Cobras. He was trying to kick-start his career in the Chinese Professional League. Mario was just 30 years old. An autopsy would later reveal he had a congenital heart condition.

In January of 2006, I traveled again to Baní to pay my respects to Encarnacion. Tejada had paid to transport Encarnacion's body back to the Dominican Republic and then paid for the funeral. That day I took a photograph of Mario Jr. lying on the floor in the living room of his apartment, a baseball bat separated from his hand in the shadow of his mother. It struck me then how much I had loved Mario, as much as any friend could love another.

Tejada and Encarnacion shared so much together and shared so much with me. In a way, we all lived an immigrant's dream. We share this story with a long line of other immigrants and the many great players in baseball history— men such as Roberto Clemente and Orlando Cepeda.

This is our story. "Baseball is Life."

Young prospects, including Miguel Tejada, right, search for a Chinese restaurant in the food court of a local mall in Scottsdale, Arizona, where they resided in 1996.

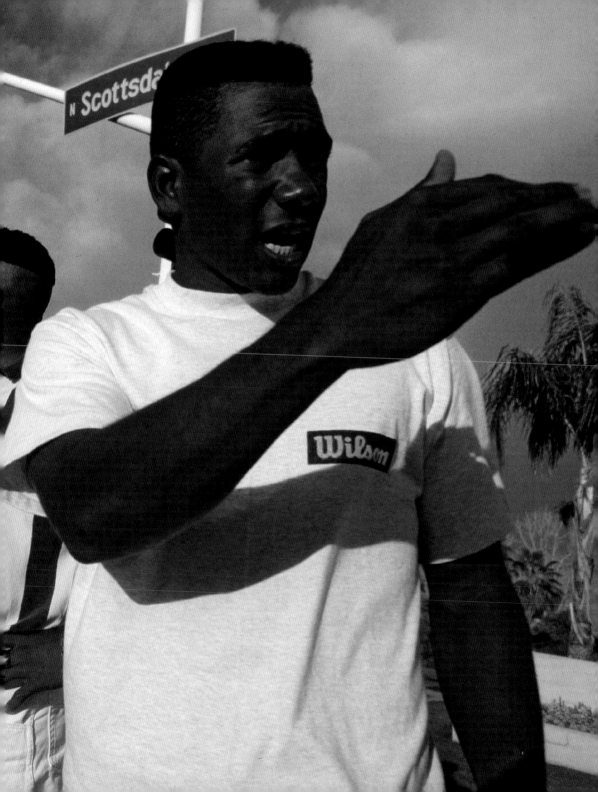

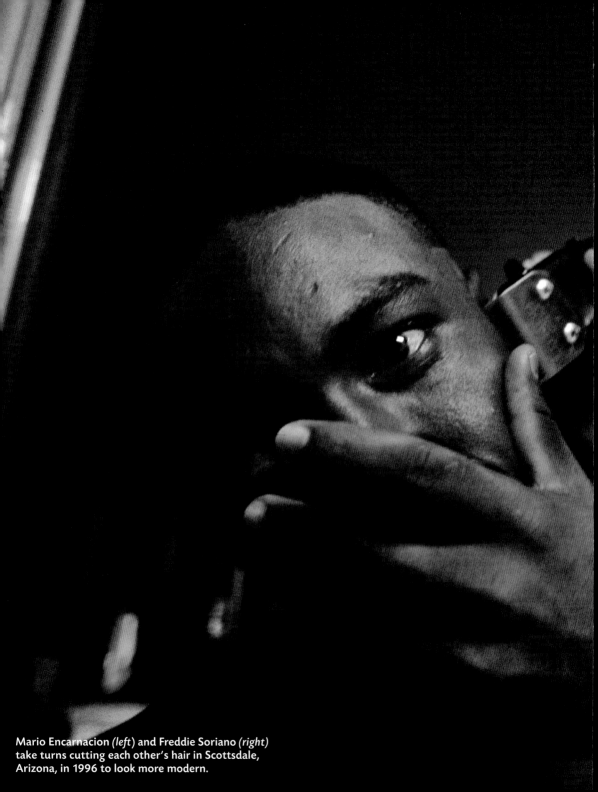

Mario Encarnacion (*left*) **and Freddie Soriano** (*right*)
take turns cutting each other's hair in Scottsdale,
Arizona, in 1996 to look more modern.

With time to spare because of an injury, Tejada likes to go the Vintage Faire Mall in Modesto, California, and imagine all the things he could buy when he became a big league ballplayer. Minor leaguers like him wore jeans and T-shirts. Big leaguers wore tailored suits.

In Modesto, all the other Latinos on Tejada's team would gather around his locker *(center)*, to listen to his stories. Tejada's position as a leader among Latino players grew visibly stronger each day.

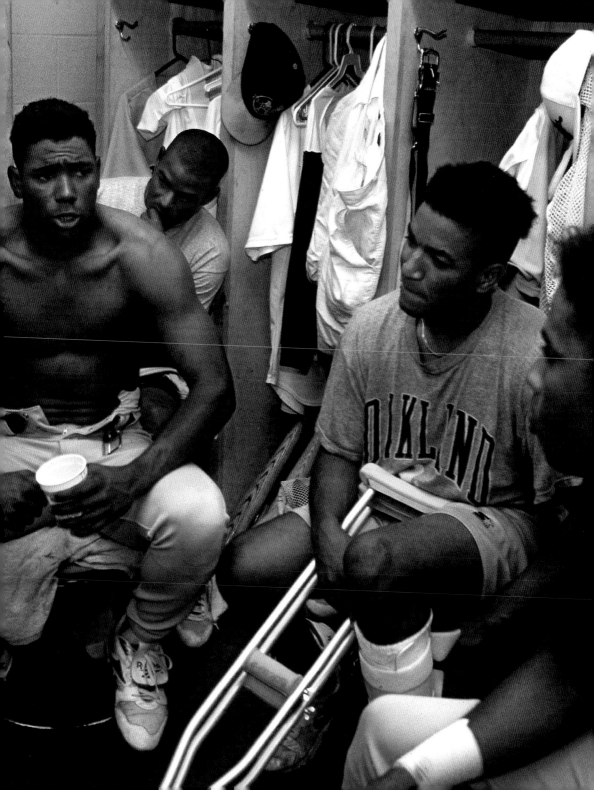

Tejada lives in a bungalow on an alfalfa farm in Modesto to save money while he plays in the minor leagues in 1996. While his host was at work, Tejada would watch TV until it was time to go to the ballpark.

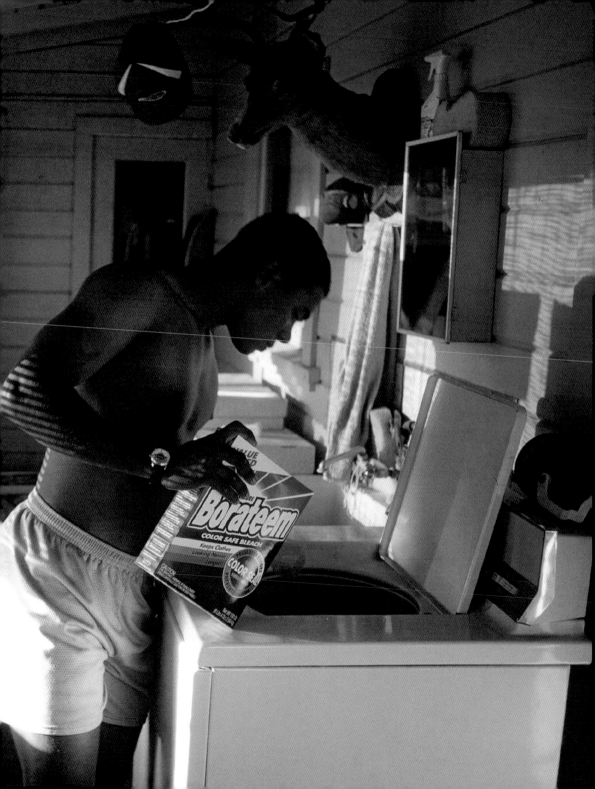

In 1997, Miguel Tejada returns to the barrio of his youth as a major league ballplayer. As his car drove down his old street, with people running on either side, he rolled down the window and screamed *"Mi gente, Mi gente!"* My people, my people.

A top prospect with the Oakland Athletics in 1996, Mario Encarnacion stands with his mother, Porfiria, at their home in Baní, the Dominican Republic.

On his first day in Scottsdale, Arizona, in 1996,
Encarnacion is lost in thought inside an American
mall. He struggled with homesickness later.
Never having known his father, Encarnacion
had been the man of the family

Mario (*third from the left*) associates with his Latino teammates while playing for the West Michigan Whitecaps in Grand Rapids, Michigan, in 1996. Difficulty with English hindered Mario's ability to make friends with his American teammates or be interviewed by the local press.

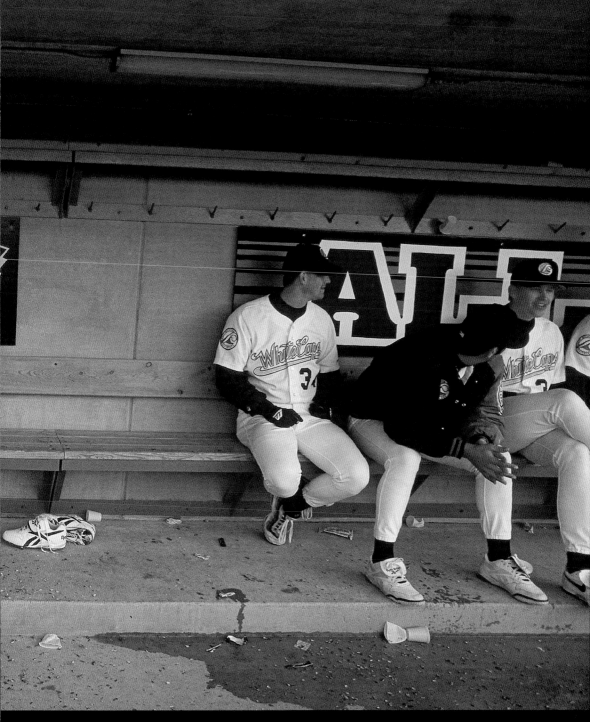

Victor Encarnacion runs his fingertips across the name of his brother engraved on his tomb in Baní, Dominican Republic.

as his mother,
o explain her
eral in 2006.

Miguel Tejada walks down the stairway of his home in Baní, the Dominican Republic, as he prepares to leave for a winter league game in Santo Domingo in 2006.

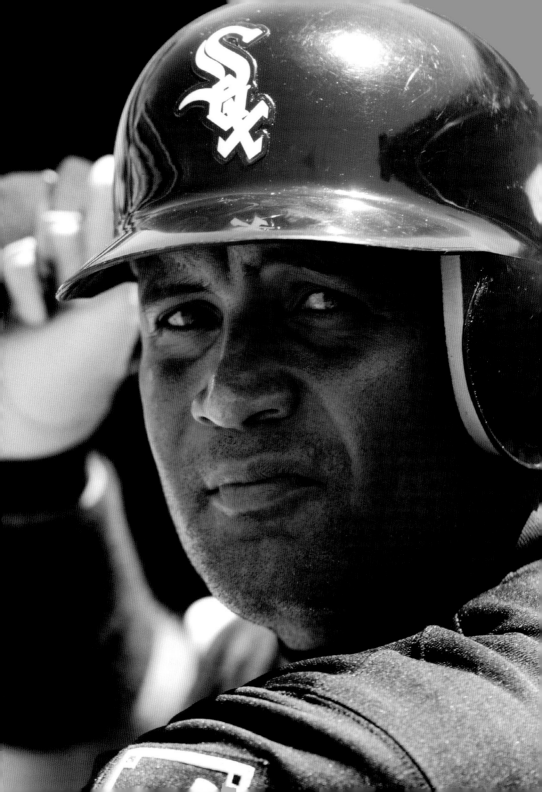

HEROES

What's the difference between a ghost and a legend? It may depend upon who remembers you in the end, or if you allow yourself to fade away. Better, as Dylan Thomas once said, to rage against the dying of the light.

Remembrance, perseverance, even rage. That's why Davey Concepcion, Juan Marichal, Orlando Cepeda, the Alou brothers and so many of the Latino stars remain icons long after their playing days have ended. In the end it's the stories that we treasure and refuse to forget. Sometimes such memories come full circle, back to a father and a son like Sandy Alomar Sr. and Jr. Both were able to find a place at the highest rungs of the professional game. Now that's something worth talking about, worth remembering. Too often, in our modern age, we do ourselves a disservice by so easily dismissing the past.

Of course, baseball is a sport built upon the past. But history does not always have to be an old photograph or a box score from a game played long ago. History can be flesh and blood, too. It can have a voice.

"I'll be talking about all the guys on those teams as long as I'm able," said Joe Morgan, the former second baseman for the Cincinnati Reds, the night he reunited with his teammates to honor Davey Concepcion. Morgan was standing in the Great American Ball Park in Cincinnati surrounded by Sparky Anderson, Johnny Bench, Tony Perez, George Foster and Lee May. Together these guys were the "Big Red Machine," the best ball club ever seen in this corner of the Midwest. It was the night the Reds would retire No. 13, Concepcion's jersey, in 2007. After the ceremony, Concepcion and Perez hugged.

"I wouldn't have missed this day for anything in the world," Perez said. "Davey and I were roommates. We looked out for each other. We helped each other become what we needed to be to succeed. That's how things should be. That's how I always tell people things should be."

Opposite:

LIKE FATHER, LIKE SON

A highly regarded catcher with a twenty-year career behind him, Sandy Alomar Jr. followed in the footsteps of his father, Sandy Alomar Sr., who played second base, and alongside his brother, Roberto, who also played second base.

OAKLAND, CALIFORNIA
2004

Below:

LUIS OLMO

The first player from Puerto Rico to play in the World Series, Olmo had a six-year career at the major league level. Olmo was inducted into the Caribbean Baseball Hall of Fame in 2004.

Opposite:

FELIPE ALOU

The first Dominican to play regularly in the major leagues, Alou had a distinguished 17-year career. After his playing days were over, he managed the Montreal Expos and, later, the San Francisco Giants.

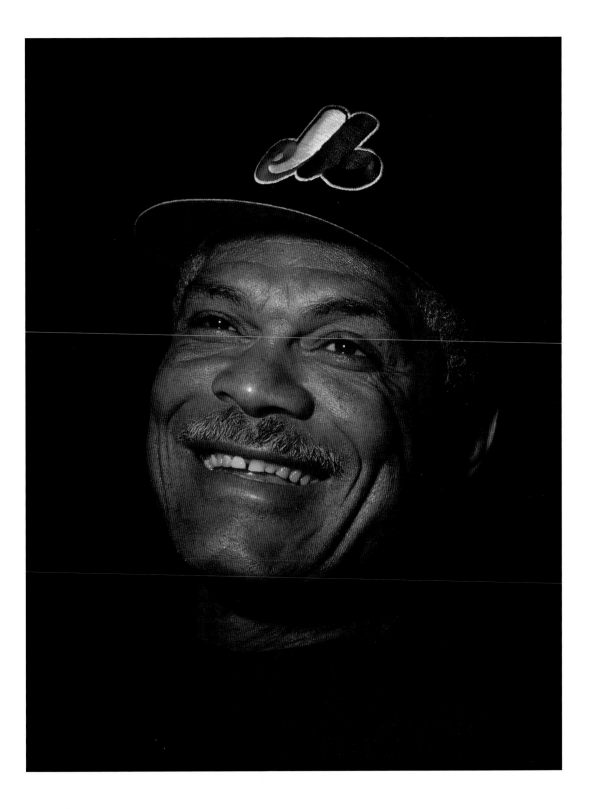

Opposite:

FERNANDO VALENZUELA

A six-time All-Star, Valenzuela was the first player to win the Rookie of the Year and Cy Young awards in the same year. After his playing days, he became a color commentator for the Los Angeles Dodgers' Spanish radio broadcasts.

Above:

ALFONSO "CHICO" CARRASQUEL

The first in the long line of Venezuelan shortstops, Carrasquel once played 53 consecutive games without an error. He died in 2005.

TONY OLIVA

An eight-time All-Star, Oliva played 15 seasons in the big leagues—all for the Minnesota Twins. In the spring, he can usually be found instructing young players at the Twins' training complex in Fort Myers, Florida.

ROD CAREW

Before entering the National Baseball Hall of Fame in 1991, Carew led the American League in hitting seven times. In addition, he was the AL Most Valuable Player in 1977. He helped many young players as the hitting coach for the Anaheim Angels.

Opposite:

DAVEY CONCEPCION

A nine-time All-Star and five-time Gold Glove winner, Concepcion saw his jersey number—lucky No. 13— retired by the Cincinnati Reds in 2007. In Venezuela he owns a share of a winter ball team where he was a player-manager for years.

Below:

CESAR GERONIMO

An integral part of the Cincinnati Reds' "Big Red Machine," Geronimo won four Gold Gloves in center field. After he retired, he became a coach at a baseball academy in his native Dominican Republic.

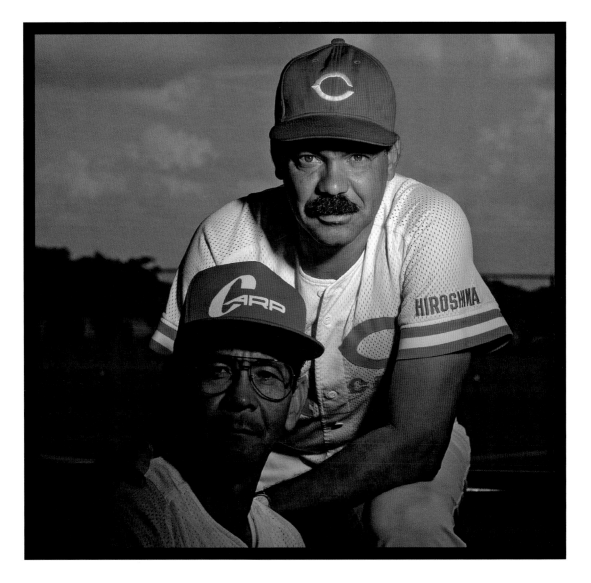

Below:

ORESTES "MINNIE" MIÑOSO

The American League hit leader in 1960, Miñoso was on the All-Star team seven times during his 17-year career. In retirement, he remained in the Chicago area, where he is as beloved as retired basketball player Michael Jordan.

Opposite:

JUAN MARICHAL

A fixture in the San Francisco Giants rotation for 14 years, Marichal was an All-Star player nine times. He was elected to the National Baseball Hall of Fame in 1983 and he now serves as minister of sports in the Dominican Republic.

ORLANDO CEPEDA

The seven-time All-Star was elected into the Hall of
Fame in 1999 and went on to work for his old ball club,
the San Francisco Giants.

VIC POWER

He played for 12 years in the major leagues and won the Gold Glove Award seven consecutive years for defensive excellence at first base. He died of cancer in 2005.

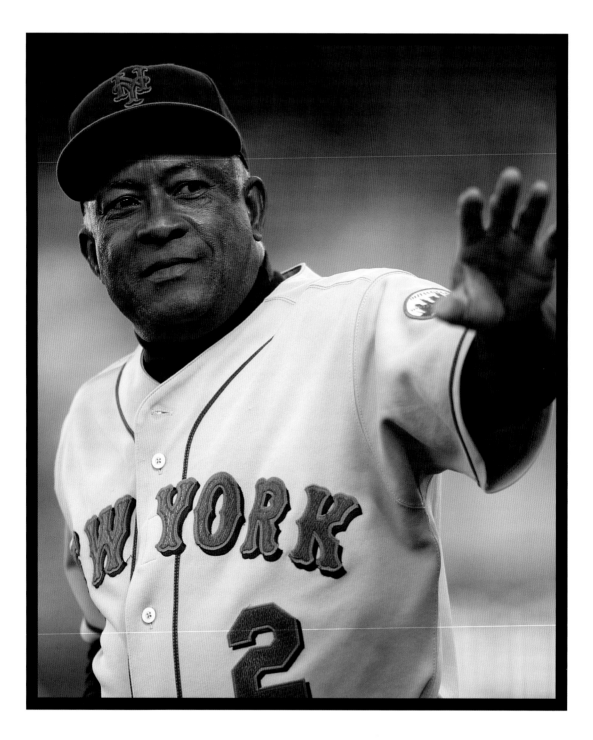

Opposite:

SANDY ALOMAR SR.

He played for 15 years at the major league level. His sons—Roberto and Sandy Jr.—also starred in the big leagues.

Above:

TONY PEREZ

He played 23 seasons in the major leagues. He was elected into the Hall of Fame in 2000 and worked in the front office for the Florida Marlins.

1878, HAVANA, CUBA

TIME LINE

1878
First league baseball game in Cuba (Habana versus Matanzas).

Nemesio Guillo, a Cuban studying in the United States, brings the first bat and ball home to Cuba.
1864

Estebam Bellan becomes the first Latino to play professionally in the United States when he takes the field in Troy, N.Y.
1871

Cubans escaping the Ten Years War form the first baseball teams in the Dominican Republic. The struggle against colonial Spain causes many Cubans to settle in Puerto Rico, Mexico and Venezuela, and they bring the game with them. The Cubans are known as "the apostles of baseball."
1868—1878

First game between U.S. and Cuban ball clubs (Almendares versus Hop Bitter from Massachusetts.)
1878

1943

Millionaire Jorge Pasquel of the Mexican League lures Satchel Paige, Roy Campanella, Josh Gibson, Mickey Owen and Danny Gardella south of the border to play. MLB commissioner Happy

Chandler declares the Mexican League an "outlaw" operation and players there could face a lifetime ban from the majors. The players are eventually reinstated after a lawsuit by Gardella.

1949
Orestes "Minnie" Miñoso breaks in with Cleveland but soon moves on to become a crowd favorite with the Chicago White Sox. The seven-time All-Star is considered by many to be the Latino Jackie Robinson—the first dark-skinned star from the Caribbean.

1950
Chico Carrasquel from Venezuela arrives in the major leagues and begins a line of slick-fielding shortstops from that country, which includes Luis Aparicio, Dave Concepcion and Omar Vizquel.

1902

Luis Castro from Colombia becomes the first Latino to play in the American league when he takes the field for the Philadelphia Athletics.

1911

Rafael Almeida and Armando Marsans become the first Cubans to play in the major leagues when they take the field for the Cincinnati Reds. They are followed by Adolfo Luque, who was nicknamed "The Pride of Havana." A feisty right-hander, Luque compiled a 194-179 record in 20 seasons in the majors. In the 1933 World Series, his 4 $\frac{1}{3}$ shutout innings in relief secured victory for the New York Giants in the deciding game.

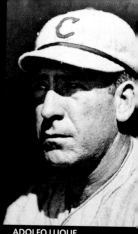

ADOLFO LUQUE

Martin Dihigo begins to play for the Cuban Stars in the Negro Leagues. Unlike Luque, Dihigo wasn't light-skinned and therefore couldn't play in the U.S. major leagues. His professional debut comes a quarter-century before Jackie Robinson breaks the color barrier

1923

in the U.S. As a pitcher, Dihigo won a reported 256 games in the Negro League. He went on to be enshrined in four Halls of Fame —Venezuelan, Cuban, Mexican and the U.S. one in Cooperstown. In short, he's the best player who was never allowed to play in the big

leagues. Despite the color barrier, 39 Cubans will reach the major leagues by 1946, thanks in large part to Joe Cambria, the legendary scout for the Washington Senators.

Ted Williams is called up by the Boston Red Sox. His mother, May Venzor, was Mexican-American. Later the Hall of Fame in Cooperstown sells a T-shirt with a list of Latino sluggers that includes Williams's name.

1939

1954

Bobby Avila from Mexico is the first foreign-born Latino to win the AL

1955

Puerto Rico's most famous ballplayer, Roberto Clemente, wasn't made to feel very welcome upon his arrival in the big leagues.

Pirates' spring training came, he is labeled as a "hot dog" by one of the local papers. He is soon followed by another Puerto Rican star,

1959

Fidel Castro, a self-professed aficionado of the game, rises to power in Cuba. In moving the country toward socialism, Castro declares that Cubans will no longer play professionally in the major leagues. Thus ends Cuba's reign as the top exporter of baseball talent to the U.S.

958

elipe Alou from the ominican Republic reaks in with the San rancisco Giants. He ill soon be joined by rothers Matty and Jesus, s well as Hall of Fame itcher Juan Marichal.

1961

Between them, Clemente and Cepeda capture the National League Triple Crown. Clemente led the league in hitting and Cepeda in home runs and RBIs.

1964

In his first full season in the majors, Cuban slugger Tony Oliva wins the American League batting title. He does it again the following season.

Rod Carew, who was born in the Canal Zone in Panama, is the new second baseman for the Minnesota Twins.

1967

After being traded from San Francisco to St. Louis, Orlando Cepeda becomes the first unanimous choice for the National League MVP Award.

DANNY GARDELLA *(left)* WITH JORGE PASQUEL

1998

Sammy Sosa, who grew up in poverty in the Dominican Republic, challenges Mark McGwire for the single-season home run record.

1997

Cuban defector Livan Hernandez is the World Series MVP for the Florida Marlins. A few weeks later, his half-brother, Orlando "El Duque" Hernandez, escapes from Cuba and becomes another clutch performer in

1999

Ivan Rodriguez (Puerto Rico) narrowly edges pitcher Pedro Martinez (Dominican Republic) to become the first catcher to win the American League MVP since

2001

Albert Pujols, who was born in the Dominican Republic, starts for the St. Louis Cardinals. His statistics soon draw comparisons with Hall of Famers Joe DiMaggio

1991

Dennis Martinez of Nicaragua hurls a perfect game for the Montreal Expos. He also leads the National League in ERA, shutouts and complete

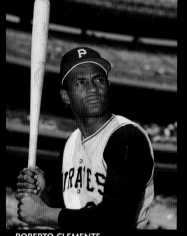

ROBERTO CLEMENTE

1971

Roberto Clemente leads the Pittsburgh Pirates to the World Series, where they defeat the favored Baltimore Orioles. Clemente is the series MVP, hitting .414 and starring in the field.

Afterward, in the victorious clubhouse, Clemente begins the national television interview in Spanish, thanking his parents back in his native Puerto Rico.

1972

In his last at-bat of the season, Roberto Clemente picks up his 3,000th career hit, a double to left-center field. On New Year's Eve, he dies in a plane crash carrying food and supplies to the victims of an earthquake in Nicaragua.

Tony Perez (Cuba) and Davey Concepcion (Venezuela) lead the Cincinnati Reds, aka "The Big Red Machine," to the World Series crown.

1975

Rod Carew has a .388 batting average, falling eight hits shy of becoming the first player since Ted Williams in 1946 to hit better than .400 at the major league level.

1977

With his pitching staff depleted, Los Angeles Dodgers manager Tommy Lasorda gives the Opening Day start to a 20-year-old Mexican left-hander, Fernando Valenzuela. The newcomer responds with a five-hit shutout.

1981

Tony La Russa, who grew up in a Spanish-speaking household in Tampa, is the manager of the Oakland A's. They sweep their cross-bay rivals, the San Francisco Giants, in the World Series.

1989

2002

New York Yankees manager Joe Torre names four shortstops to the AL All-Star squad (Derek Jeter, Nomar Garciaparra, Omar Vizquel and Miguel Tejada) behind starter Alex Rodriguez. All are of Latino descent except Jeter.

Omar Minaya is named the general manager of the Montreal Expos.

ALBERT PUJOLS

2003

Mexican-American Arte Moreno becomes the first Latino owner when he purchases the Los Angeles Angels from the Walt Disney Co.

2006

"Los Mets," led by Carlos Beltran and Carlos Delgado and rising start Jose Reyes, reach the National League championship only to lose to Albert Pujols's St. Louis Cardinals.

2007

Currently Dominican-born major leaguers outnumber every country except the U.S.

Opposite:

THE END

A baseball player waits for the ball in center field at twilight.

WAYNESBORO, PENNSYLVANIA

ACKNOWLEDGMENTS

Often the lasting memory of writing a book, the real fun of it, is the people you meet along the way. Time after time, Bronwen Latimer was there for guidance and support. A top-notch editor, I could always count on her enthusiasm and expertise to carry the day.

Thanks to Kevin Mulroy for the opportunity to write for National Geographic Books and to Dale Petroskey for opening the door. It's an honor to see my words run alongside the stunning photographs of José Luis Villegas and other great artists.

As with several of my previous projects, I'd have been lost without the patient folks at the National Baseball Hall of Fame and Library in Cooperstown, N.Y. Over the years, those who have assisted me include Bill Francis, Ted Spencer, Tom Schieber, Bruce Markusen, Jeff Idelson and Eric Enders. A special nod to my friends on the beat—Alan Klein, Rob Ruck, S.L. Price, Rick Lawes, Victor Baldizon, Pete Williams, Adrian Burgos, Tim Gay and Milton Jamail.

More than a decade ago, Paul White, then editor of *USA Today Baseball Weekly,* sent me out to cover baseball on a national basis. Years later, I realize that much of what I know about the game is a result of his early confidence in me.

And, finally, thanks to those waiting at home plate—Jacqui, Sarah and Chris. Few things are better in life than taking your family to a ballgame, teaching them to keep score, and in doing so having the chance to see the grand old game with fresh eyes once again. **—TIM WENDEL**

In memory of my parents Consuelo and Manuel Villegas, this book is for you. I am living your dream, the dream of opportunity all immigrants have for themselves and for their children. I am forever grateful for your gift. To my brothers and sisters—Connie, Carmen, Jane, Gloria, Manuel, Maria, and Lorenzo—thank you.

To Mario Encarnacion, Miguel Tejada and their families, thank you for allowing us into your family life so we could tell the story of the true journey a Latino baseball player takes. To the Oakland Athletics and the many other Latino baseball players who shared stories with us, thank you.

Special thanks to National Geographic Society, The National Baseball Hall of Fame, and the Santa Fe Workshop for their support. To my friends Sam Abell and Leah Bendavid-Val, thank you for believing in me and my work. To my friends, Rick Rodriguez and Mark Morris of *The Sacramento Bee,* thank you. To my fellow photographers—Jim Gensheimer, Emmett Jordan and John Trotter—thank you for your friendship and input throughout the project. To Marcos Bretón, your friendship and contribution to the research of the Latin Baseball Project over the past 15 years has been invaluable. I love you my brother.

To my wife, Ruth, my number one supporter and soulmate over twenty years, I love you. To my children—Jimmy, Jacqueline and Jeraline—live your dreams.

Viva Beisbol!

—JOSÉ LUIS VILLEGAS

PHOTO CREDITS

Cover, Brad Mangin/MLB Photos.
Photo Essay 112-137, All photographs by José Luis Villegas.
2-3, David Alan Harvey/Magnum Photos; 4, John Williamson/MLB Photos; 6-7, Louis Requena/MLB Photos;8-9, Walter Iooss Jr./Sports Illustrated; 10-11, Simon Bruty/Sports Illustrated; 12-13, Walter Iooss Jr./Sports Illustrated; 14-15, José Luis Villegas; 16-17, John Grieshop/MLB Photos; 18-19, David Burnett/Contact Press Images; 20, The National Baseball Hall of Fame/MLB Photos; 22-23, David Alan Harvey/Magnum Photos; 25, Library of Congress; 26-27, Mark Rucker/Transcendental Graphics/Getty Images; 29, Mark Rucker/Transcendental Graphics/Getty Images; 30, Mark Rucker/Transcendental Graphics/Getty Images; 31, AP/Wide World Photos; 32-33, National Baseball Hall of Fame Library/MLB Photos/Getty Images; 34, Mark Rucker/Transcendental Graphics/Getty Images; 36-37, Mark Rucker/Transcendental Graphics/Getty Images; 38, AP/Wide World Photos; 39, AP/Wide World Photos; 40-41, AP/Wide World Photos; 41 (RT), AP/Wide World Photos; 42-43, Mark Kauffman/Time Life Pictures/Getty Images; 45, AP/Wide World Photos; 46, Bettmann/CORBIS; 47, Walter Iooss Jr./Sports Illustrated; 48, Gilberto Ante/Roger Viollet/Getty Images; 50-51, Sven Creutzmann/Mambo Photography/Getty Images; 52, Louis Requena/MLB Photos; 53, Roberto Schmidt/AFP/Getty Images; 55, Victor Baldizon/MLB Photos; 56-57, José Luis Villegas; 59, AP/Wide World Photos; 60, Neil Leifer/Sports Illustrated; 63, Walter Iooss Jr./Sports Illustrated; 64-65, Louis Requena/MLB Photos; 66, Morris Berman/MLB Photos; 67, MLB Photos; 68, MLB Photos; 70-71, Rich Pilling/MLB Photos; 72, Rich Pilling/MLB Photos; 73, Louis Requena/MLB Photos; 74-75, Louis Requena/MLB Photos; 75, Tony Tomsic/MLB Photos; 77, Tony Tomsic/MLB Photos; 78-79, Brad Mangin/MLB Photos; 81, Rich Pilling/MLB Photos; 82, AP/Wide World Photos; 83, Andrew D. Bernstein/Getty Images; 85, Christopher Anderson/Magnum Photos; 86-87, Victor Baldizon/MLB Photos; 89, José Luis Villegas; 90, José Luis Villegas; 91, Ron Vesely/MLB Photos; 92, Victor Baldizon/MLB Photos; 94-95, Victor Baldizon/MLB Photos; 96, Michael Zagaris/MLB Photos; 97, Rick Pilling/MLB Photos; 98, Robert Beck/MLB Photos; 98-99, John Grieshop/MLB Photos; 100, Brad Mangin/MLB Photos; 101, Rich Pilling/MLB Photos; 102-103, Don Smith/MLB Photos; 104, Michael Zagaris/MLB Photos; 105, Jon Soohoo/MLB Photos; 106, Stephen Dunn/Getty Images; 107, Rich Pilling/MLB Photos; 108, MLB Photos; 109, Rich Pilling/MLB Photos; 110-111, José Luis Villegas; 138, Brad Mangin/MLB Photos; 140-145, José Luis Villegas; 146, AP/Wide World Photos; 147-152, José Luis Villegas; 153, Paul Spinelli/MLB Photos; 154, Courtesy Ralph Paniagua/www.latinobaseball.com; 155 (UP), Courtesy Ralph Paniagua/ww.latinobaseball.com; 155 (LO), MLB Photos; 156, Mark Rucker/Transcendental Graphics/Getty Images; 157 (UP), Louis Requena/MLB Photos; 157 (LO), José Luis Villegas; 158, Raymond Gehman.

FAR FROM HOME
LATINO BASEBALL PLAYERS IN AMERICA

Tim Wendel and José Luis Villegas

Published by the National Geographic Society

John M. Fahey, Jr., *President and Chief Executive Officer*

Gilbert M. Grosvenor, *Chairman of the Board*

Nina D. Hoffman, *Executive Vice President;*
 President, Book Publishing Group

Prepared by the Book Division

Kevin Mulroy, *Senior Vice President and Publisher*

Leah Bendavid-Val, *Director of Photography*
 Publishing and Illustrations

Marianne R. Koszorus, *Director of Design*

Barbara Brownell Grogan, *Executive Editor*

Elizabeth Newhouse, *Director of Travel Publishing*

Carl Mehler, *Director of Maps*

Staff for This Book

Bronwen Latimer, *Editor and Illustrations Editor*

Cinda Rose, *Art Director*

Cameron Zotter, *Assistant Designer*

Rich Pilling, *Illustrations Consultant, MLB Photos*

Paul Cunningham, *Illustrations Consultant, MLB Photos*

Eric Enders, *Researcher*

Sarajane Herman, *Copy Editor*

Mike Horenstein, *Production Project Manager*

Robert Waymouth, *Illustrations Specialist*

Jennifer A. Thornton, *Managing Editor*

Gary Colbert, *Production Director*

Manufacturing and Quality Management

Christopher A. Liedel, *Chief Financial Officer*

Phillip L. Schlosser, *Vice President*

John T. Dunn, *Technical Director*

Chris Brown, *Director*

Maryclare Tracy, *Manager*

Nicole Elliott, *Manager*

Founded in 1888, the National Geographic Society is one of the largest nonprofit scientific and educational organizations in the world. It reaches more than 285 million people worldwide each month through its official journal, NATIONAL GEOGRAPHIC, and its four other magazines; the National Geographic Channel; television documentaries; radio programs; films; books; videos and DVDs; maps; and interactive media. National Geographic has funded more than 8,000 scientific research projects and supports an education program combating geographic illiteracy.

For more information, please call
1-800-NGS LINE (647-5463)
or write to the following address:

National Geographic Society
1145 17th Street N.W.
Washington, D.C. 20036-4688 U.S.A.

Visit us online at
www.nationalgeographic.com/books

For information about special discounts
for bulk purchases, please contact
National Geographic Books Special Sales:
ngspecsales@ngs.org

For rights or permissions inquiries,
please contact National Geographic Books
Subsidiary Rights: ngbookrights@ngs.org

Library of Congress Cataloging-in-Publication Data available upon request

ISBN: 978-1-4262-0216-2

Printed in China